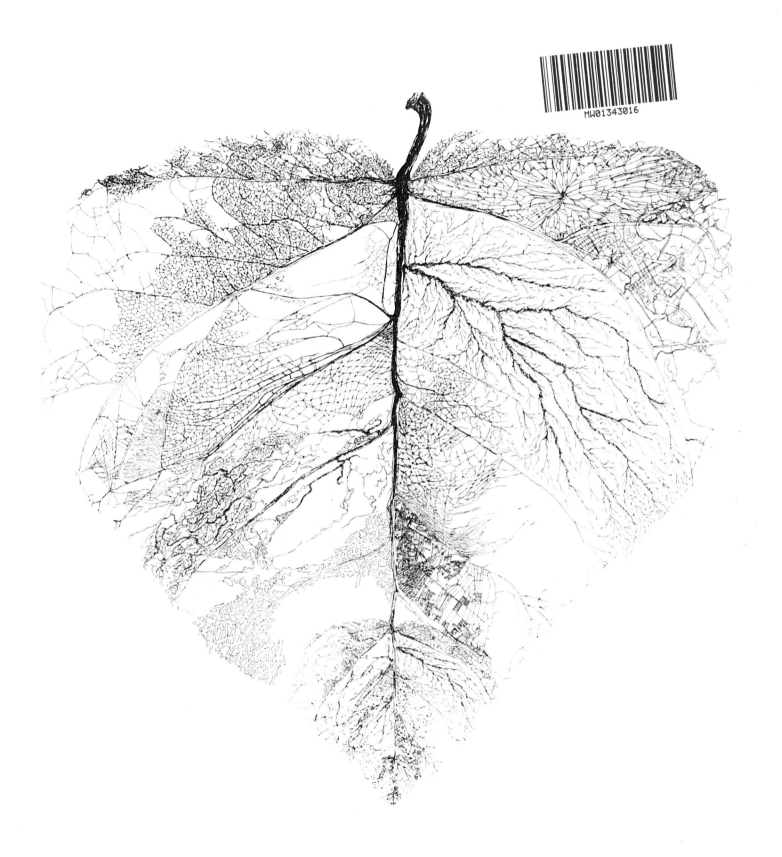

ESSENTIAL MYSTERIES
IN ART AND SCIENCE

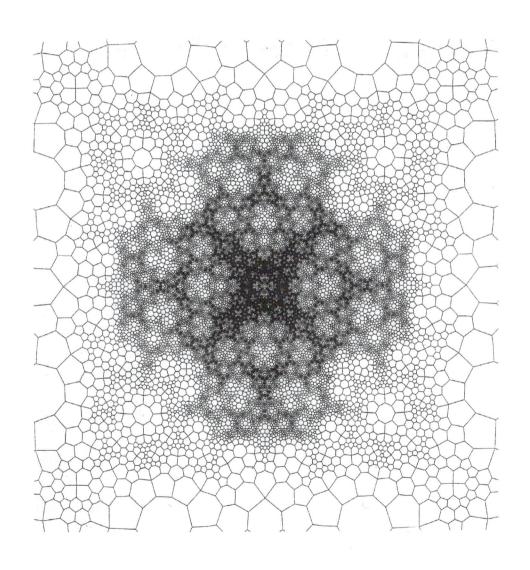

ESSENTIAL MYSTERIES
IN ART AND SCIENCE

Trudy Myrrh Reagan

2020

Copyright © 2020
Gertrude Myrrh Reagan
All Rights Resevred.

Second Printing

ISBN Number 978-0-9967056-8-4

For information about the author, visit myrrh-art.com.

Flyleaf pages: "Leaf," 1970, pen and ink, 21" X 21"

Half Title page: "Group Theory"
Courtesy of Prof. James Cannon

Computer-generated figure from the study of higher mathematics.
A diagram used in the center of my painting, Emergence.

Acknowlegements

To my husband Daryl Reagan, who taught me so much.

Also, Russell Reagan for his editorial work.

And encouragement from Ralph Abraham, Robert and Carol Chatfield, Craig Comstock and Shoshanah Dubiner, Michael Diggles, Robert Ishi, Elad Levinson, Roger Malina, Sonya Rapoport, Dale Seymour, Larry Shaw, Dr. Gerald Silverberg, Zachery Stewart, Corinne Whittaker, David Willson, and Steve Wilson.

And to those who offered their homes to me for studio space while they were away: George and Beth Mills, Lincoln and Mary Lou Moses, Maxine and Mel Solomon, Eric Roberts and Lauren Rusk, Carol and Noel Stevens, and Nancy Tector.

To Zachary Stewart, my male muse

FOREWORD
About Trudy Myrrh Reagan

In his famous 1953 essay, *The Hedgehog and the Fox*, the philosopher Isaiah Berlin (borrowing from the ancient Greek poet Archilocus and the Renaissance humanist Erasmus) divided creative thinkers into two types: hedgehogs, whose work is unitary, unwavering, and consistent; and foxes, who take a more comprehensive and diverse view, producing a more varied oeuvre. Both types of temperament are important, and complementary; there are many royal roads to creativity. A paradigmatic hedgehog artist would be the stubborn genius, Cézanne; a paradigmatic fox, Picasso, a stylistic thieving magpie, was, ironically, in his youth, highly influenced by Cézanne; another eminent fox, Leonardo da Vinci, was labeled by Sir Kenneth Clark (I quote from a not-always-reliable memory) "the most curious man who ever lived."

Science, the patterns found in nature, and sociopolitical commentary have been the apparently contradictory but abiding concerns for fifty years of the Palo Alto artist—and Berlin-classification fox—Gertrude (or Trudy) Reagan, who has gone by the professional name Myrrh for years out of distaste for a certain California politician. Myrrh, whose father was a geologist, her husband a particle physicist, and her two sons, an engineer and a scientist, shows that visual art can be a compelling and beautiful way to explore scientific phenomena from biology, geology, botany, anatomy, mathematics, physics, and even philosophy and metaphysics. Her work is a refutation of C.P. Snow's thesis that art and science are antithetical realms and cultures. In fact, she has been active in bringing together "the two cultures" of art and science, founding, in 1981, YLEM: Artists Using Science and Technology, which served as a forum for the then-developing field of computer graphics, and offering Forums for twenty-eight years on a wide range of subjects as befit her interests. It is worth repeating that Silicon Valley's computer industry developed from the marriage of cutting-edge technology and refined—user-friendly, and often irresistible—aesthetics. Although digital culture is pervasive and seductive these days, Reagan is attuned to traditional wisdom as well, studying sacred texts from both eastern and western cultures, and her artistic practice is informed by Quaker and Buddhist teachings rather than narrowly focused on the abstract issues of shape, form and color. Her website (www.myrrh-art.com) is a rich resource for those interested in further pursuing the connections between science and art.

Myrrh's 2017 solo exhibition at the Peninsula Museum of Art (Burlingame, CA), *Physical/Metaphysical: Mixed-Media Works*, showed her to be a Berlin-classification fox as well. It was a visual and intellectual delight, presenting over fifty works selected from eight diverse bodies of work, including *Patterns in Nature*,

Metaphysics, *Shibori* (a Japanese resist-dyeing technique), and *Recycling*, as well as landscapes ranging from Tenaya Peak to Wall Street; drawings and paintings of the refugees of El Salvador; and drawings, collages and prints addressing our current capitalist amorality (*Right Brain/Wrong Brain*, *Worship of the Almighty Dollar*, *Our Heads Above Water*). The range of Reagan's subject matter is as impressive as her use of a wide range of materials and media to express the ideas, succinctly and memorably. I will focus on one series as a kind of synecdoche, or detail, symbolic of the entirety.

Dominating one wall of the large Decker B Gallery were six pieces from Reagan's two-decade *Essential Mysteries* series; these abstract acrylic paintings on large (45" diameter) plexiglas discs, spectacularly span the physical universe, from the microscopically small to the cosmically large, from subatomic particles to galaxies, affirming the aesthetic beauty of the laws of science. *The World of Small and Large* juxtaposes painted hexagonal tiles depicting a solar storm, a spiral galaxy, a DNA double helix, and a view of the blue planet, swathed in swirls of clouds. In *Energy Becomes Matter*, a red-hot solar sphere, yellow and white at the center, burns beneath an outer shell of silhouetted islands or plates. In *Intertwingled* (a portmanteau word combining intertwined and mingled), the planetary orb is covered with jagged zigzag forms in different colors, suggesting mountain ranges, drainage basins, and electrical discharges. And finally, *Brains Imagine* pays tribute to human creativity, presenting a spheroid divided in halves, the two lobes of the brain, its convoluted surface composed of naked figures borrowed from that uber-hedgehog, Michelangelo, among others.

— DeWitt Cheng, curator and art critic

INTRODUCTION
Essential Mysteries Series

After years of roaming the cavernous mines of science and collecting nuggets for art, I found that what interests me most are those indeterminate areas that scientists love to explore but can never fully explain. These are some of the most intriguing questions that humans can contemplate. We see in religion and philosophy earlier attempts to treat these subjects: What is matter? What is life and what is death? What is thinking? How can we live amid chaos?

When I had two youngsters, I made them scrapbooks. I contemplated, "What do I want them to have a good grasp of?" My answer: "Where we are in space and time." There was the *Inner and Outer Space* book, with its X-rays and star pictures. We watched *Powers of Ten*, which took us by tenfold leaps from a picnic blanket in Chicago out into the stars and galaxies, and inward, to the microscopic realm. That became my life's work in art as well. To that theme I have now added emergence. I would show them a caterpillar becoming a butterfly, a baby coming from its mother's womb, and a never-before-seen volcano, Parícutin, that erupted in a farmer's cornfield in 1943 when I was in third grade, and is now very tall. I would want them to know that the evolution of animals and plants, Earth and galaxies, is a process; that emergence happens all the time, and is part of the magnificent creativity inherent in the universe.

—Trudy Myrrh Reagan

CONTENTS

v	FOREWORD	39	Energy Becomes Matter
vii	INTRODUCTION	45	Life Creates
1	**PAINTINGS**	49	Brains Imagine
2	The World of Small and Large	53	Minds Have Wanderlust
4	Number Governs Form	59	While My Art Evolved, So Did Science
6	Energy Becomes Matter	61	Complexity
8	Life Creates	63	Intertwingled
10	Brains Imagine	67	Synchrony Prevails
12	Minds Have Wanderlust	71	Death Teems with Life
14	Intertwingled	75	Catastrophe!
16	Synchrony Prevails	79	Turbulence
17	Death Teems with Life	83	Emergence
18	Catastrophe!	86	Einstein Quote
20	Turbulence	88	AFTERWORD
22	Emergence	91	Bibliography and Artist's Notes
27	**ESSAYS**	101	Picture Credits
29	The World of Small and Large		
35	Number Governs Form		

PAINTINGS

Essential Mysteries

THE WORLD OF SMALL & LARGE

From the smallest to the largest, scientists delve deep: Subatomic particles (their tracks), DNA double helix, the hands of mother and child, Earth, Sun (with solar flare), and a galaxy like our own. The curved tracks are cosmic rays, particles from outer space.

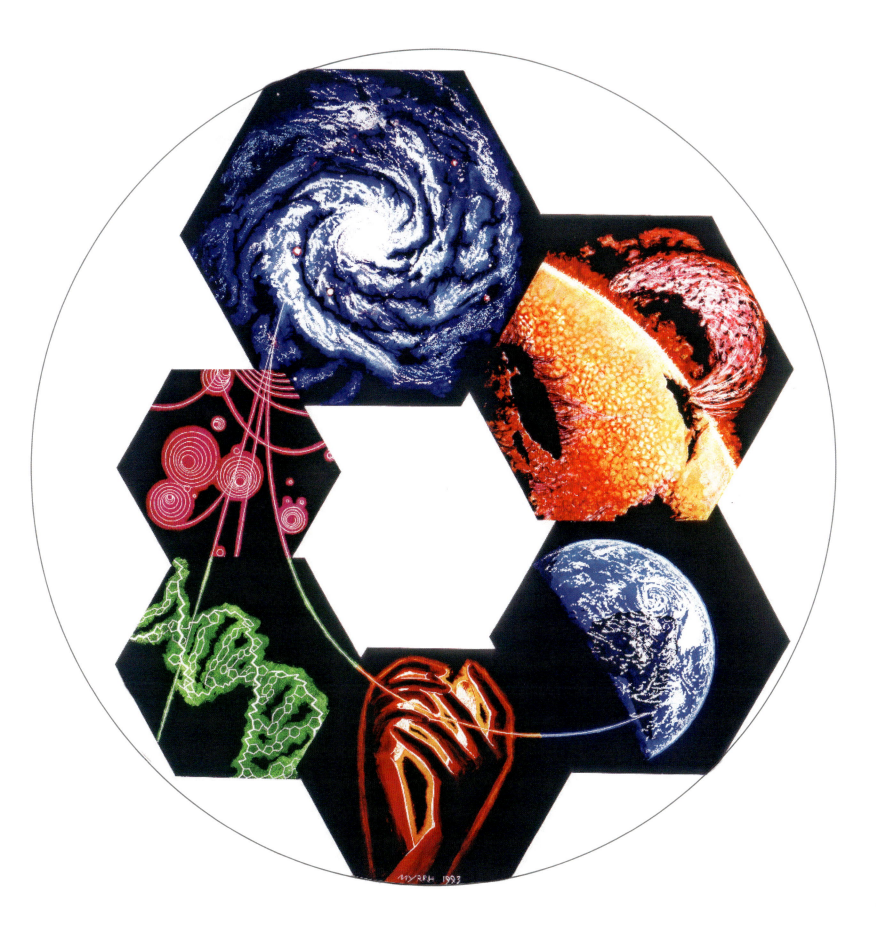

NUMBER GOVERNS FORM
Amethyst crystals and the flower of a thistle, familiar things, demonstrate orderly numerical patterns.

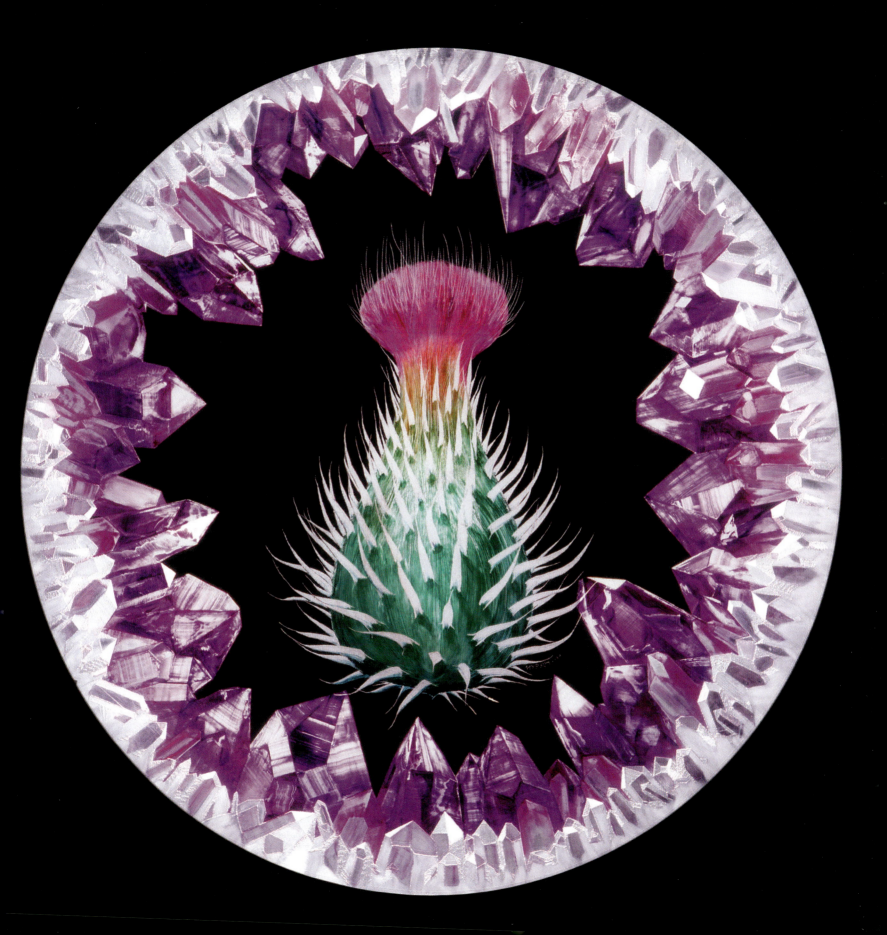

ENERGY BECOMES MATTER

Abundant energy suddenly became the Universe 13.7 billion years ago. Einstein found that energy and matter are equivalent, expressed mathematically as $E=mc^2$, where E is energy, m is mass, and c the speed of light.

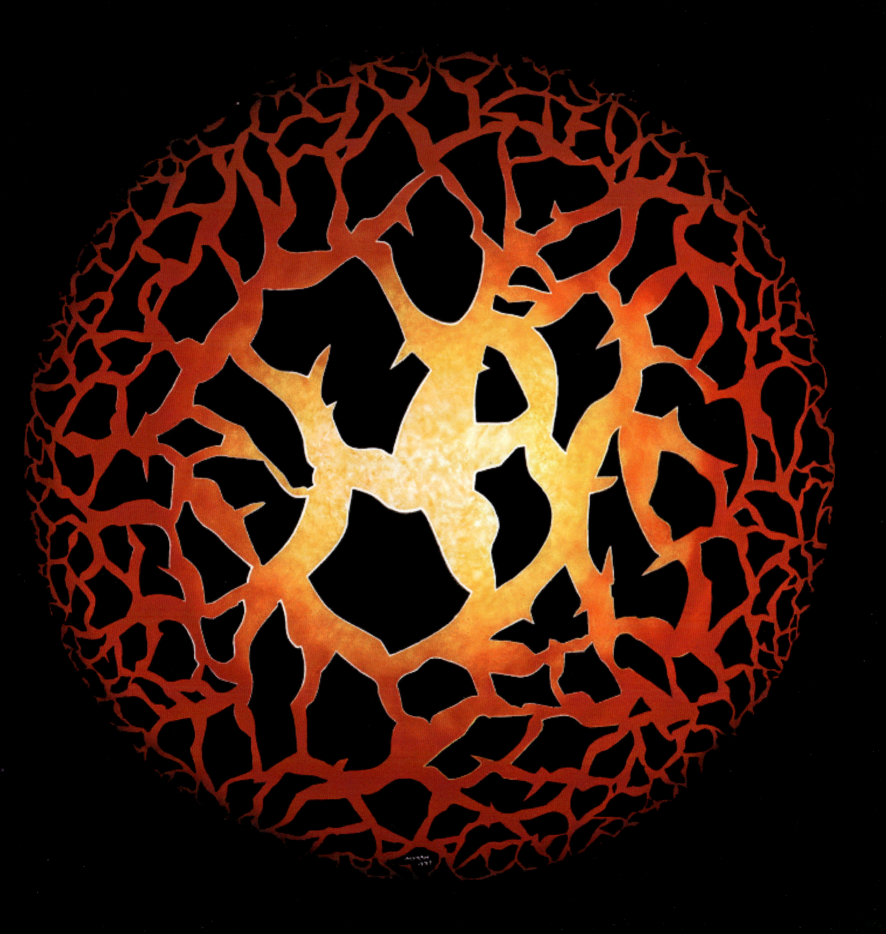

LIFE CREATES
Radiolarian diagram of a microscopic one-celled organism. The black center suggests the living protoplasm, while white lines represent the glassy cage it creates. This is the boundary between the living and inorganic.

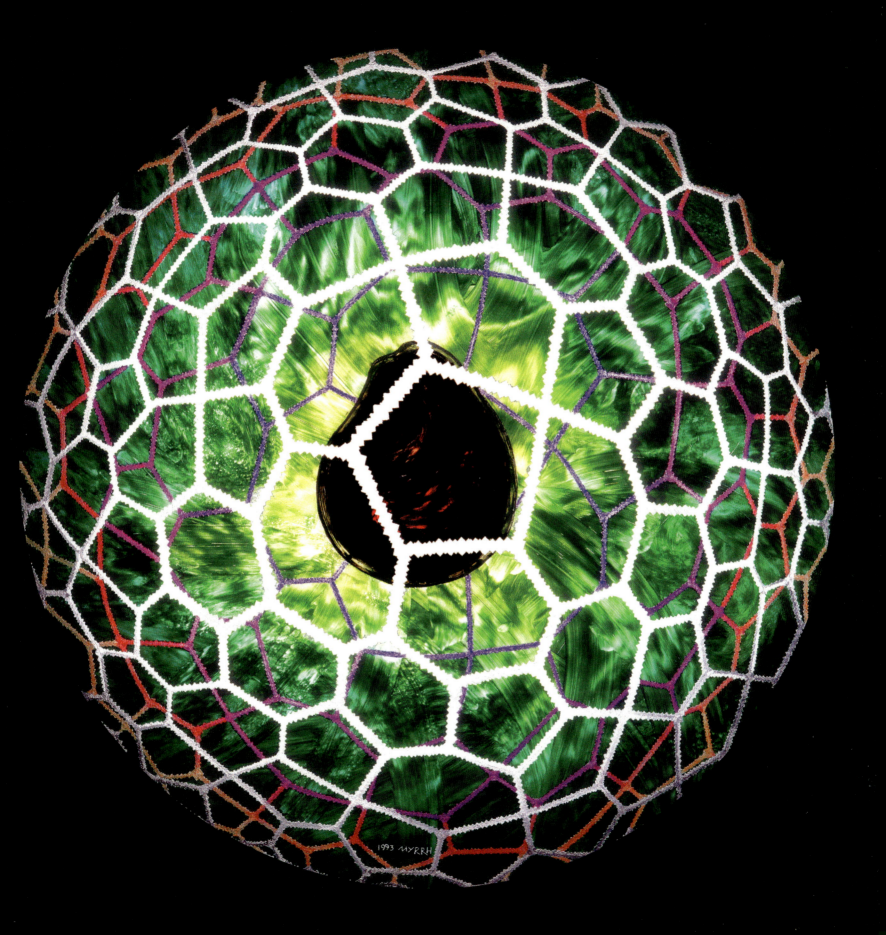

BRAINS IMAGINE

It's a mystery ... How do molecules and neurons think, and how does combining different ideas make a Eureka Moment? As you do a double-take, you observe your own brain imagining.

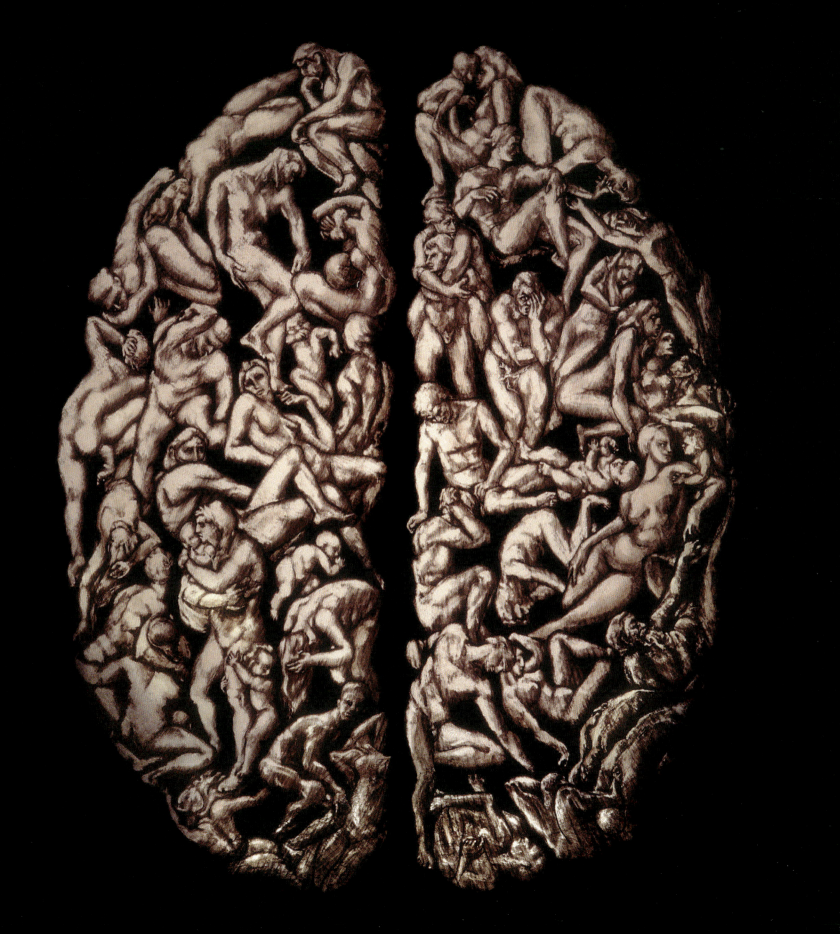

MINDS HAVE WANDERLUST

By traveling with our minds and making measurements, we can go back 13.7 billion light years, almost to the Big Bang, or detect almost 200 billion galaxies.

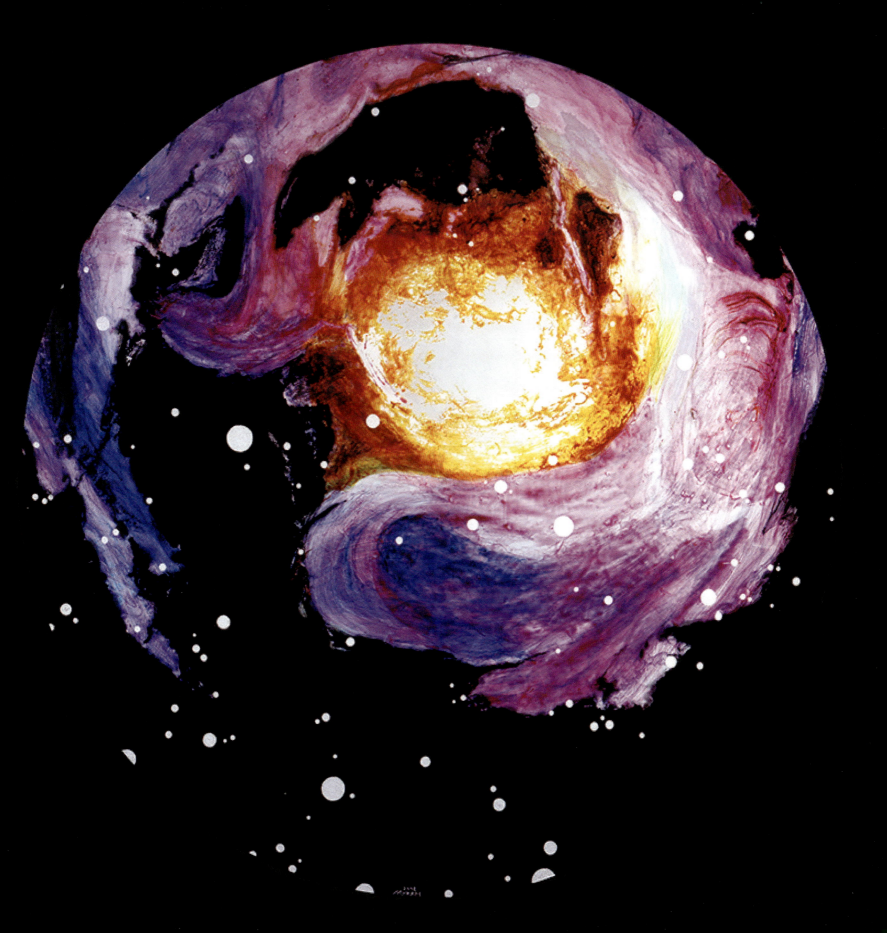

INTERTWINGLED

Colors intermingled in a maze is a simile for surprising relationships that we find everywhere. Oxygen supports every intertwined activity. Globally, billions of photosynthesizing microorganisms create the oxygen in the atmosphere, which supports almost all biological activities. The smallest scale is intertwined with a very large one, Earth itself.

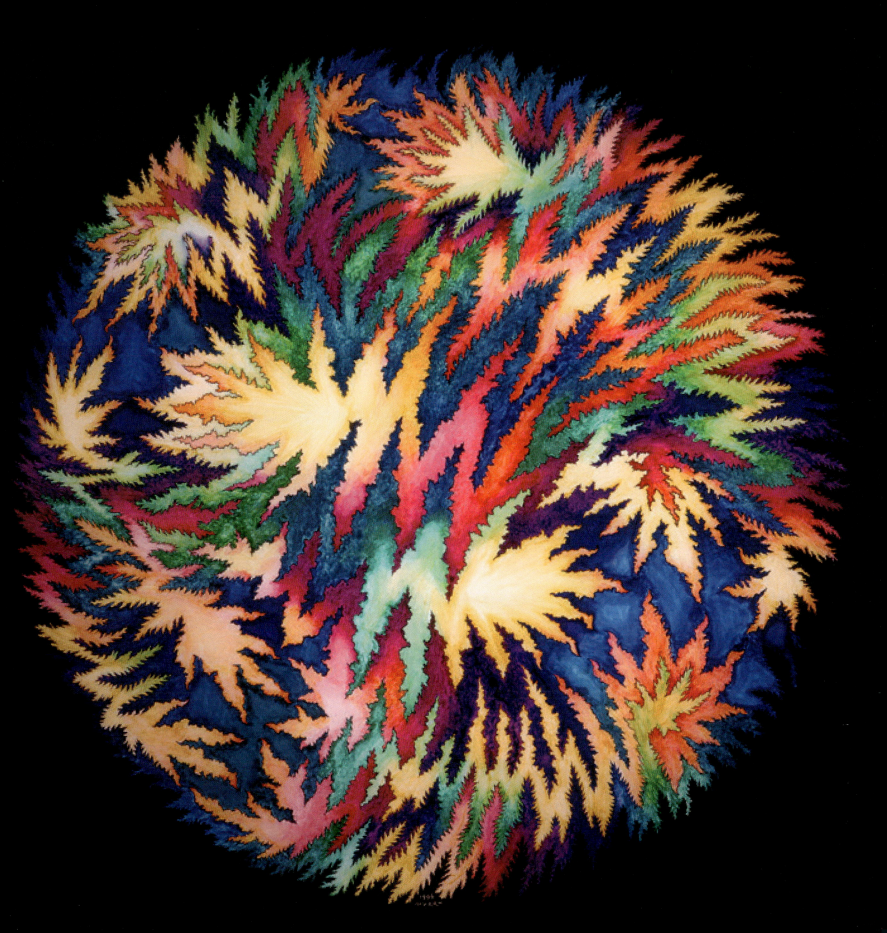

SYNCHRONY PREVAILS

Interlinked processes are churning away at the cellular level in our bodies and on a planetary scale, even now while you breathe. All are kept in synchrony by feedback loops.

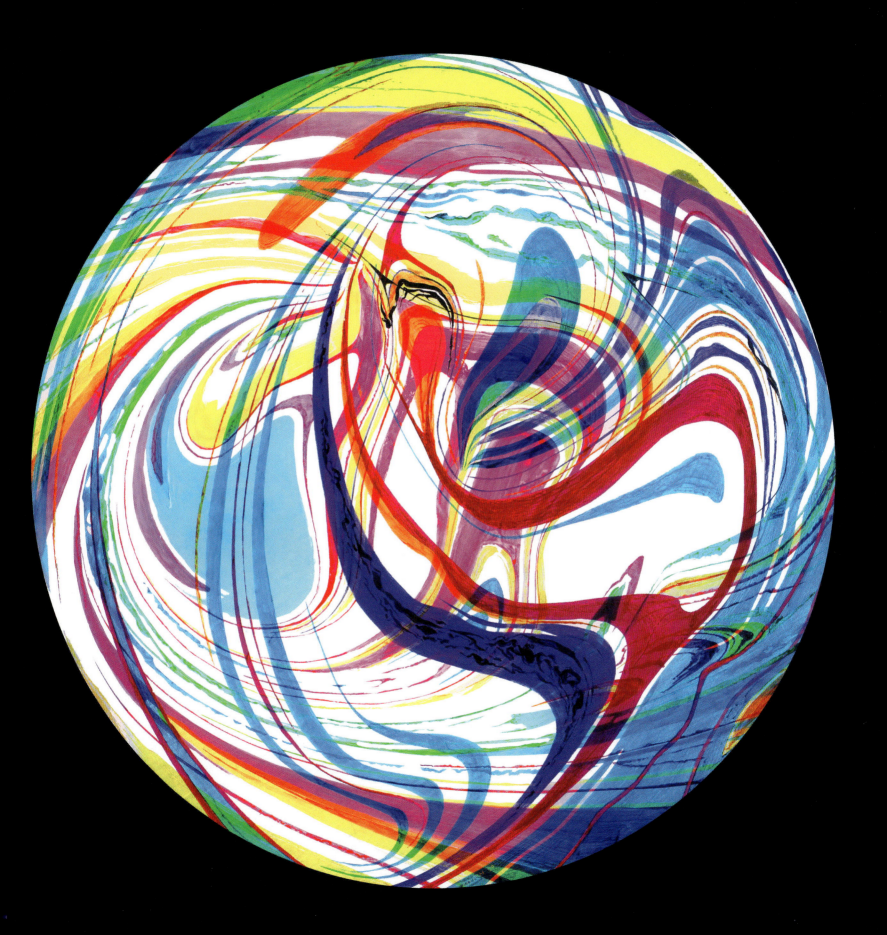

DEATH TEEMS WITH LIFE

From dust we came, to dust we return—but the dust is full of small organisms creating life out of almost nothing.

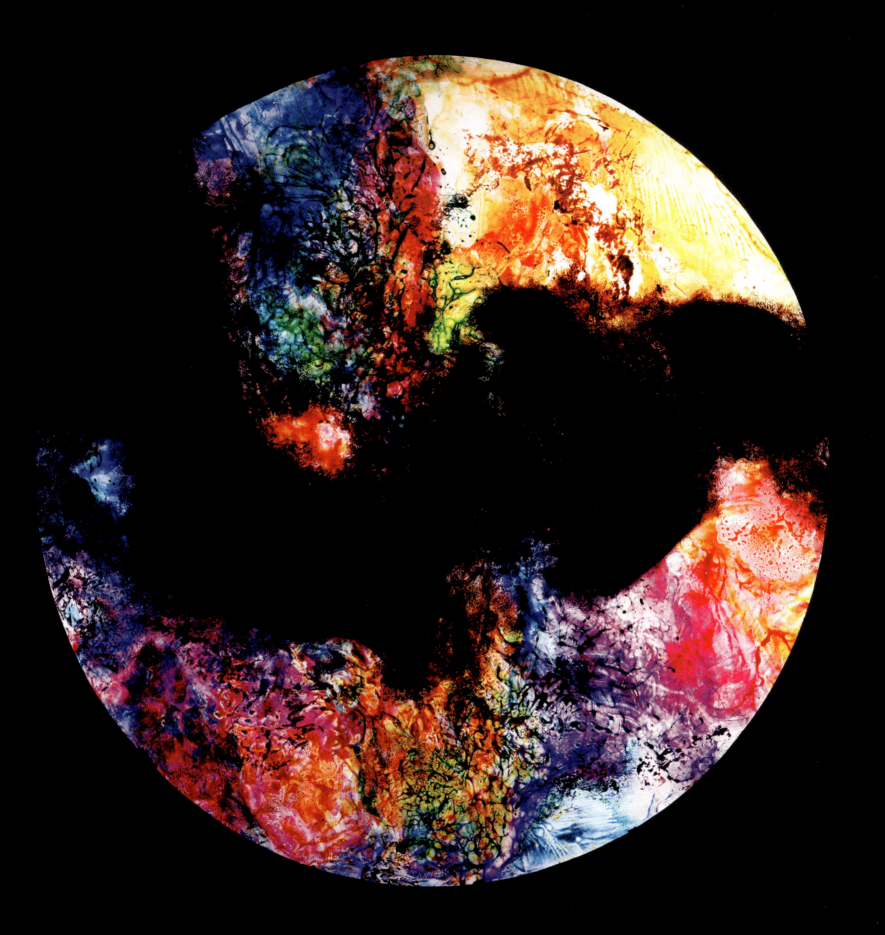

CATASTROPHE!

It's a mystery... exactly when the avalanche will hurtle down, or the stock market will tumble. How does a fallen tree branch cause a blackout in an entire electric grid? The more finely tuned a complex system is, the more it is flirting with the rare, unforeseen event.

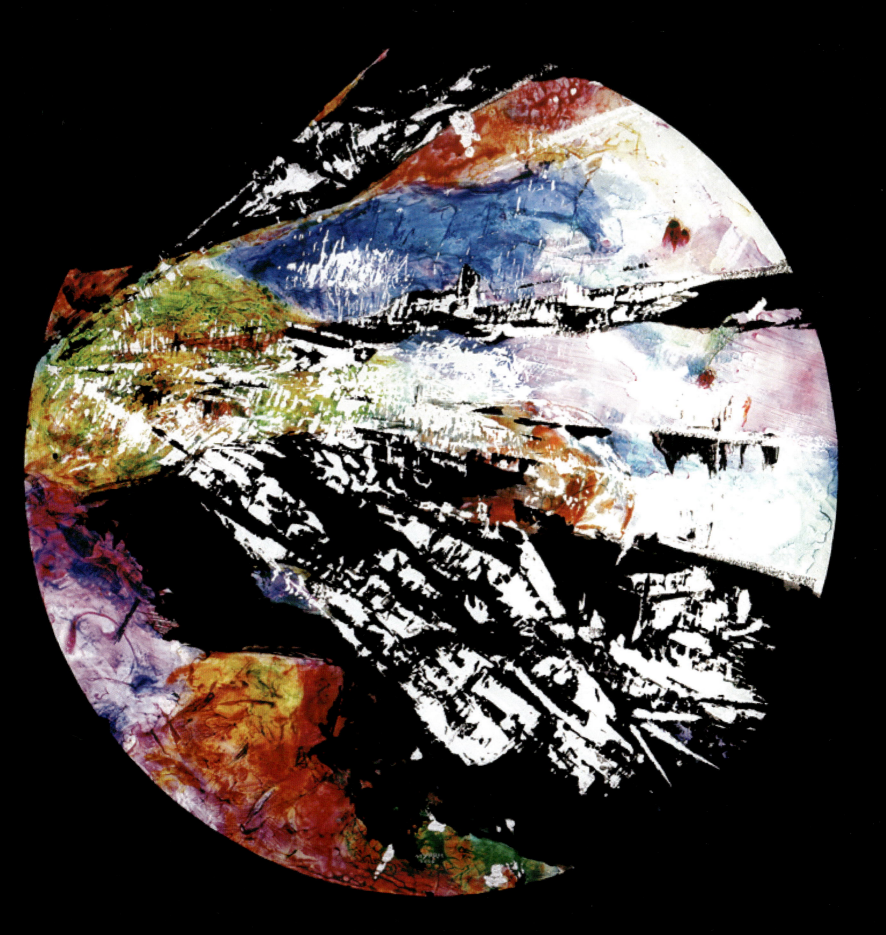

TURBULENCE

Mathematical models of fluid flow are very effective until they reach the point where fluid becomes turbulent. The simple geometric figure in the center represents our ineffective effort to understand it.

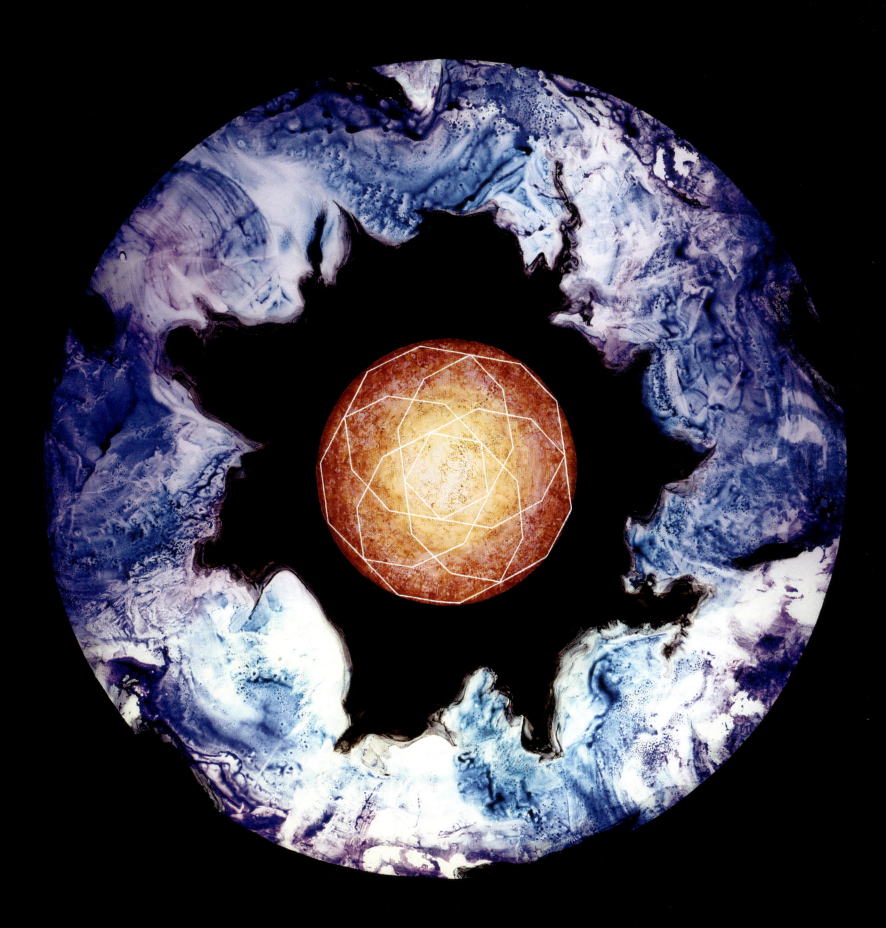

EMERGENCE

The idea that the whole is greater than the sum of its parts is called gestalt. Emergence is more than this. The individual parts grow and change in relation to each other. To understand this enables us to better grasp brain function, ecosytems, weather patterns, and the growth of cities.

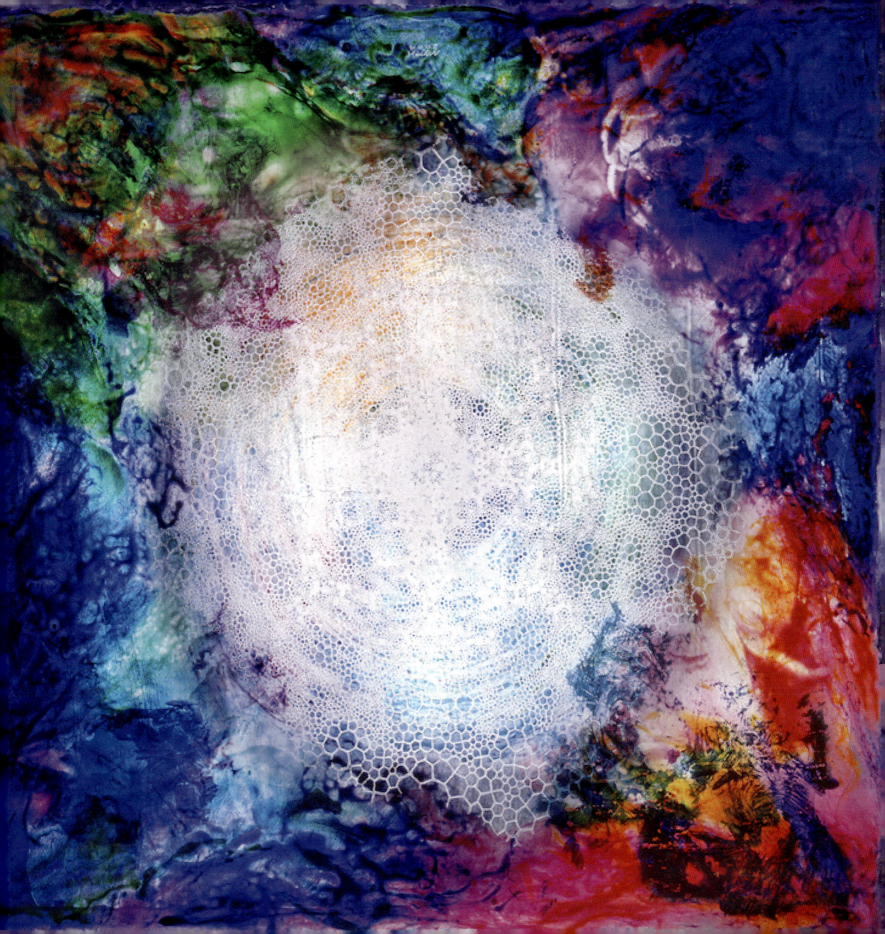

ESSAYS
Essential Mysteries

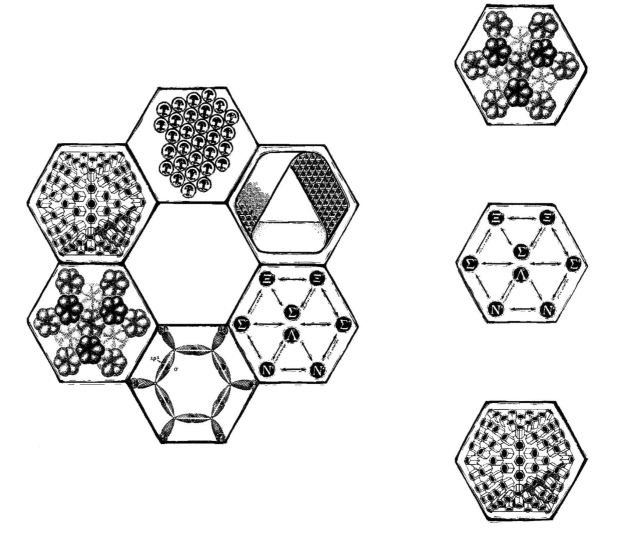

Conjecture, scratchboard, 1989, 18" X 18"
Atoms, Quark, and Virus Diagrams (right – top to bottom)

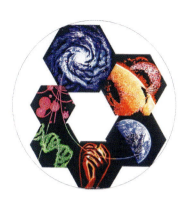

THE WORLD OF SMALL and LARGE
Essential Mysteries in Art and Science

I was elated in 1956 by *The New Landscape*, a book that showed images from science so beautiful that the author, Gyorgy Kepes, considered them art. This came when I, as an undergraduate, was struggling unsuccessfully to create original abstract art. My father was a geologist. Surrounded by colorful geologic maps, and viewing crystal structures under the microscope as a child, I suddenly realized that what I already knew could be "art."

For several years afterward I collected and used patterns in nature from science magazines and books simply for the way they looked. I decorated my small Palo Alto house with large geologic maps of Pennsylvania and Great Britain. I owe gratitude to the editors of the *Whole Earth Catalog* in 1968 for reviewing picture books to feed my interest! I was captivated by books like *Sensitive Chaos* with photographs of fluid flow, and the drawings of biological specimens by Ernst Haeckel in *Art Forms in Nature*.

As my physicist husband Daryl talked to me about the enterprise of science, and I read the introduction to a basic biology text by Garrett Hardin,[1] I gained a broader view: Particles make atoms, atoms make molecules, and molecules make visible matter—matter that lives and thinks—this is *basic* to an understanding of life on Earth. My husband introduced me to the hierarchy in outer space of planets, stars, globular clusters and galaxies, and even black holes when they were a yet-unproven mathematical concept. I wished for everyone to know this. It became the narrative structure for the rest of my art.

The World of Small and Large, painted in 1993, is based on the hierarchy of the structure of matter. I started to call it Where We Are, but when I came to the galaxy level, I learned that the Hubble Space Telescope, launched in 1990, found galaxies wherever it pointed its lens. Billions of galaxies exist, an estimated 200 billion at last count in 2018.

In this painting, the **purple hexagon** shows subatomic particles, tracks from Stanford Linear Accelerator Center (SLAC) where my husband worked. Particle detectors produced in 1970 images like this. Later computerized detectors showed much more complex details, and revealed new particles. It was in such an image that the Higgs Boson was spotted. The familiar subatomic particles are electrons, protons and neutrons. Physicists have discovered hundreds of other subatomic particles by accelerating known particles with electromagnetic energy. Many appear to be created out of pure energy.

An artist cannot possibly convey the spatial proportions in the subatomic world. If the atom were as large in diameter as the dome of *St. Peter's Basilica* in the Vatican, the nucleus in the center would be the size of a grain of salt. The electrons would be a few particles of dust swirling around it. Nevertheless, the atom behaves much like a solid lump of matter because of powerful attractive forces binding all parts together, and repulsive forces surrounding each one to form stable structures.

Subatomic particle interaction

Why does anything hold together and endure? Jacob Bronowski declared that some units at one level form stable structures that then become the building blocks for the next higher level. The chemist need only deal with atoms and need not consider subatomic particles to solve problems.

Atoms can, however, bond together into molecules under favorable conditions. As I create ice crystals on cold, wet glass, I reflect in amazement that I am seeing a pattern built of hexagonal groupings at the atomic level.

The **next hexagon is green**, the color of life. It shows the DNA molecule.

One of the successes of twentieth-century science has been to discover molecular structures and their interactions that make clear how certain biological processes work physically. For example, when the structure of DNA was discovered, the unforeseen benefit was that the way it is put together suggested how it could split apart and replicate to create offspring.

James Watson and Francis Crick wrote at the end of their paper describing the structure they discovered for DNA, "It has not escaped our notice that the specific pairing we have postulated immediately suggests a possible copying mechanism for the genetic material."[2] What an understatement! How to copy DNA was pivotal to understanding how inheritance operated at the molecular level.

Watson, while full of faith that molecular biology "will soon enable us to understand all the basic features of the living state," nevertheless admitted that the molecules in question were so large and complex, and so numerous, "that the structure of a cell will never be understood in the same way as that of water or glucose molecules."

The orange hexagon shows two hands, one of the mother, the other of her child. Hands are a particularly potent symbol for humankind. According to the anthropologist Peter Reynolds early humans probably organized themselves when assembling tools. He visualizes small face-to-face teams dividing the tasks to make stone tools tied onto handles with their version of glue, for instance. He has observed aboriginal tribesmen doing this, but chimpanzees cannot. To keep the work going, some form of language could naturally have evolved. "It is precisely this type of socially organized and cooperative division of specialized labor for the achievement of a specific goal that is *never* (his italics) seen except in human tool manufacture and use."[3] The idea that handwork may have led to language development is intriguing.

In September 2018, scientists reported the discovery of the earliest known drawing by *Homo sapiens*, which is estimated to be 73,000 years old. The oldest examples of figurative cave paintings are somewhat younger, close to 35,000 years old. Only humans paint. And their hands made instruments: Not just one, but a number of flutes from the European Upper Paleolithic have been discovered.[4]

Human heart

In my painting, the hands are placed mid-way between the subatomic and the cosmic. Astrophysicist Joel Primack observed: "The size of a human being is at the center of all the possible sizes in the universe" from the smallest particle (10^{-25} cm) to the outer reaches of space (10^{30} cm). Our unique consciousness and position makes us a privileged observer.[5]

The next hexagon is the **blue ball of Earth** from space revealed by space travel. My father had me draw the globe of Earth in space for his book, *The Evolution of North America* in 1959. It looks funny to us now, because I didn't visualize any clouds covering it. We have Stewart Brand to thank for NASA's first release of pictures showing it. In 1966, after an LSD trip when he had visions, he said, "Why haven't we seen the whole Earth from space yet?" He did numerous publicity stunts to pester the space agency, and was investigated by the FBI. In 1967 we began to see NASA photos of the whole Earth. The *Whole Earth Catalog*, which followed in 1968, was also his brainchild. The image was an inspiration for the first Earth Day in 1970.

The **surface of the Sun is shown in red**. (It's a seething plasma, different from solid, liquid or vapor, a fourth state of matter entirely.) Solar flares are stormy events, with solar wind that causes aurora borealis at night on Earth. The solar storm of September 28, 1859 was observed world-wide, and zapped the brand new electrical telegraph systems. To give you an idea of the size of Earth, it is a speck on the solar flare.

The galaxy is shown in the large dark blue hexagon. The view that we have of our galaxy is edge on. It is probably a spiral galaxy. At the center is a black hole.

The innovative educator Maria Montessori in 1948 wrote about our basic understanding of where we are in the world:

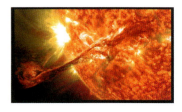

Solar flare

> In school they want children to learn dry facts of reality, while their imagination is cultivated by fairy tales, concerned with a world that is certainly full of marvels, but not the world around them in which they live. On the other hand, by offering the child the story of the universe, we give him something a thousand times more infinite and mysterious to reconstruct with his imagination, a drama no fable can reveal.
>
> If the idea of the universe be presented to the child in the right way, it will do more for him than just arouse his interest, for it will create in him admiration and wonder, a feeling loftier than any interest and more satisfying. The child's mind then will no longer wander, but becomes fixed and can work. The knowledge he then acquires is organized and systematic; his intelligence becomes whole and complete because of the vision of the whole that has been presented, and his interest spreads to all, for all are linked and have their place in the universe on which his mind is centered. The stars, earth, stones, life of all kinds form a whole in relation to each other, and so close is this relation that we cannot understand a stone without some understanding of the great sun! No matter what we touch, an atom, or a cell, we cannot explain it without knowledge of the wide universe.
>
> What better answer can be given to those seekers for knowledge? It becomes doubtful whether even the universe will suffice. How did it come into being, and how will it end?[6]

Virus, batik, 1977, 15" Hexagon
(part of *Animal, Vegetable, Mineral*, an 18-hexagon wall hanging), 1977

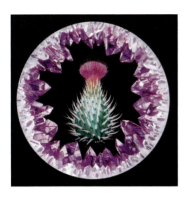

NUMBER GOVERNS FORM
Essential Mysteries in Art and Science

In this painting, you notice amethyst crystals and the flower of a weed, the prickly Scotch thistle. I deliberately chose things that you or I can pick up on a walk in the woods, and painted them from actual specimens. I examined a geode, a curious hollow rock where crystals gradually grow inward because dissolved silica seeps into it. While drawing the flower, the only way I could keep a thistle flower from becoming thistledown was to freeze one! How number governs: Crystals come in just 17 basic geometric shapes.[1] Growth processes through time create patterns. Many plant leaves, seeds or petals grow in a pattern based on Fibonacci Numbers, a numerical sequence that creates lovely spirals.[2]

We have been looking for patterns in nature for eons. Twenty-eight marks on a cave-dweller's bone, dated 28,000 BCE, seem to record phases of the moon. Similar artifacts studied by Alexander Marshack all over Europe in the Magdalenian prehistoric period often show the marks grouped in sevens.[3] In this respect, we are lucky we didn't live on cloudy Venus! Astronomer Fred Hoyle wrote, "Without sight of regular rhythmical movements of Sun and stars across the sky, we would have found it next to impossible to grasp the very concept of time".[4]

Timing in the expression of genes is important in pattern formation that makes the scales on fish or butterfly wings and everything that happens in the growth of a complex organism from a single cell.

We often think that genes code for specific body parts. However, most genes work by coding proteins that interact with each other in fantastic order in space and time. On a fish, there is a basic body-plan "kit" of genes, which regulate its size and proportion. Each species has its characteristic combinations at work. "Evo Devo" (evolutionary development) is the study of these relationships.

The actions of certain genes can be exaggerated; others might not even be used, varying in each type

Fibonacci pinecone diagram

Fibonacci numbers show every quarter turn is farther from the origin by a factor of phi, 137°, called the golden ratio.

of cell or animal species, e.g. fishes in the dark with no eyes. Nature is very efficient in its use of the multiude of variations to produce different species. Small changes in how one gene regulates many others can result in significant changes. This sheds light on both patterns and evolution.[5]

All patterns are constrained by how matter itself is allowed to go together. This is where mathematics becomes useful.

Moving down to the subatomic level, it is all mathematics.

My husband was a particle physicist at Stanford Linear Accelerator Center (SLAC) from 1963 to 1993, during which a zoo of elementary particles was being discovered at high energies. He loved explaining that, using mathematics, physicists suspected the existence of many things yet undiscovered: antimatter, black holes, neutrinos ... and through the years that I followed this, they were discovered!

In 1960, Eugene Wigner wrote an article titled "The Unreasonable Effectiveness of Mathematics in the Natural Sciences." He concluded, "The miracle of appropriateness of the language of mathematics for the formulation of the laws of physics is a wonderful gift which we neither understand nor deserve." (He was referring to physics and chemistry more than biology and geology, where historical accidents play a big role).[6]

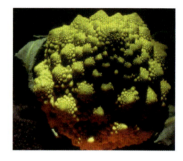

Romanesco broccoli: fractal form

This view, that mathematics discovers the inherent order "out there," relates to that of Plato, who taught that there is a "real" world of ideal objects, of which we can merely see examples in the material world.

When discussing particle physics, we need to understand the incomprehensibly small interior of the atom, for it is totally outside normal experience.

Recently, I have studied more, and learned from Max Tegmark, a physicist and mapper of galaxies. He writes: "[The] crazy-sounding belief [is] that our physical world not only is described by mathematics but that it is mathematics ... A mathematical structure, to be precise.

"Everything ... Seems to be made of particles ... These particles are purely mathematical properties—numbers with names like charge, spin and lepton number."[7]

When I arrived at this level, I felt as if I had traveled to the ocean depths in a bathysphere!

We may look at nature through the eyes of the inventive computer programmer and philosopher, Rudy Rucker:

> Even if we could find a complete and correct explanation of our world's physics, this would only be a static piece of information—perhaps an initial condition and a set of rules. The interesting things

happen as the consequences of the laws unfold. The unfolding process is a computation carried out by the world itself.[8]

This would certainly apply to growth patterns like the ones I painted.

Jacob Bronowski, science historian who authored *The Ascent of Man*, traces human curiosity about the deep structure of matter to humans' discovery of how to work with the natural cleavage of wood and stone:

> The notion of discovering an underlying order in matter is man's basic concept for exploring nature. The architecture of things reveals a structure below the surface, a hidden grain which, when it is laid bare, makes it possible to take natural formations apart and assemble them into new arrangements." [On his television documentary, he split slate into flat slabs].
>
> For me this is the step in the ascent of man at which theoretical science begins" ... "[S]pace is just as crucial part of nature as matter is, even if (like the air) it is invisible; that is what the science of geometry is about. Symmetry is not merely a descriptive nicety; like other thoughts in Pythagoras, it penetrates to the harmony in nature.[9]

The ancient Greek, Pythagoras, and his followers about 2500 years ago held the fundamental idea that only through number and form can man grasp the nature of the universe.

I once asked June Wayne, an artist who often used science ideas in her art, why she called her lithograph of a DNA strand *Thou Shalt Not*. She replied, "We think of DNA as defining what will be. As well, it eliminates what shall not be." The same limiting principle may be said about the mathematics of particles, and what can and cannot be.[10]

Succulent plant. Fibonacci numbers show every quarter turn is farther from the origin by a factor of phi, 137°, called the golden ratio.

Lacy leaves—fractal form

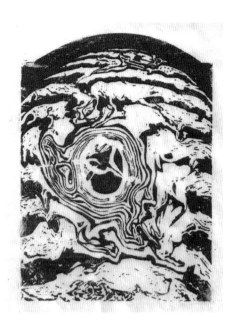

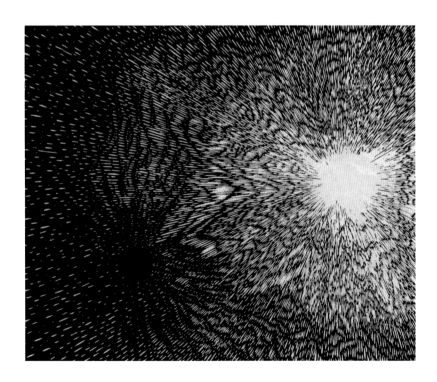

Plasma, block print, 6"X 8", 1973
Black Hole, block print, 1970, 11" X 14"

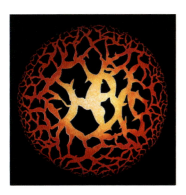

ENERGY BECOMES MATTER
Essential Mysteries in Art and Science

Energy Becomes Matter and matter becomes energy: Such a strange statement! Yet it is the meaning of the famous equation by Einstein, $E = mc^2$, or energy equals mass times the speed of light squared.

How could the Universe have started from nothing? How can we possibly visualize such a thing? We can't. The Big Bang certainly did *not* look like an exploding bowling ball. Nor could we even conceive of looking at the Universe from outside itself—yet this was the best I could do as a painter to begin a discussion about it. Cosmologist Philip Gibbs writes: "In a conventional explosion, material expands out from a central point. A short moment after the explosion starts, the centre will be the hottest point ... [with] a spherical shell of material expanding away from the centre ... The Big Bang—as far as we understand it— ... was an explosion of space, not an explosion in space. According to the standard models there was no space and time before the Big Bang. There was not even a 'before' to speak of ..."[1]

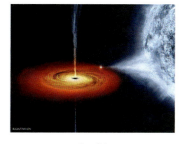

Painting of a blue star losing itself to the gravity pit of the black hole.

How do we know this happened? Actually, for years we didn't. When I was a young woman back in the 1960s, two theories about the origin of the Universe were being debated. The other alternative was the "steady state" theory that Sir Fred Hoyle proposed. As some stars and galaxies die, others are born to take their place, for eternity.

Distances in space are measured in light years, the distance that light travels in one year. Astronomer Edwin Hubble was the first to do precise galaxy distance and speed measurements in light years combining two methods: calculating the distance from Earth (by measuring the luminosity of Cepheid variable stars); and measuring the red shift of galaxies, (the redder the light of one on a spectrograph, the faster it is moving away).

A Cepheid is a star whose characteristics allow it to become our standard for brightness. When it is dim, it is distant; if bright, it is nearby. He was using this thirty-year-old discovery, and the then-new Palomar telescope. Hubble studied the Andromeda galaxy, a fuzzy object visible in the sky on a very dark night. To his surprise, individual stars within it could be discerned. He measured the Cepheids in it and found

it was 2,540,000 light years from us, a distance that astonished everyone, for few guessed it was a galaxy *outside* our own Milky Way. Up to that time almost everyone thought the Milky Way was the entire Universe.

A personal note: My husband Daryl was born in 1925. This was three years before Hubble's discovery. When I awoke on a camping trip on a beach in 1970 and spotted it, I loved thinking about this. How many galaxies do exist? The latest guess is nearly 200 billion![2]

Star charts showed many blurry "nebulosities." They proved to be galaxies also. Light from a luminous object, whether it be a flame or a star, can be viewed through a prism in a spectroscope. We see a complete spectrum of color if the object emits all wavelengths of light. The chemical composition of a star causes a characteristic pattern of lines to appear as gaps in the spectrum. If this pattern shifted toward the red end of the spectrum, it means the star is fleeing away, the famous "red shift."

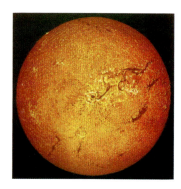

Sun's surface seething

Hubble's spectroscope measurements showed that all stars and galaxies outside our local group were traveling away from us, and the further away the galaxy, the faster it was fleeing—suggesting that the entire Universe was expanding. Almost incomprehensible! Almost immediately in 1931, two different cosmologists, Alexander Friedman and Abbé Georges Lemaître, played this movie backwards, speculating that the Universe began with a "Big Bang." At such a beginning, space objects would be much closer together than now, they thought, perhaps down to a single point! The idea wasn't taken seriously. The "steady state" theory seemed more likely.

Nor was the Big Bang taken seriously in 1946 when proposed by George Gamow. Could this even be proved? He speculated the explosive birth would still be reverberating weakly, leaving a remenant: background radiation. In 1968, Robert Wilson and Arno Penzias found radiation not quite 3 degrees above absolute zero. (This is cold! Absolute zero is -273°C). No matter where in the sky they pointed their instruments, it was there. It was the missing evidence for the Big Bang. If the steady state had been correct, it would have been neither hotter nor denser than today.[2] Three degrees is very faint. It is strange to be able to measure something so distant. And it is strange that, without direct visual evidence, we can glean the information that this all happened between 13.7 and 13.8 billion years ago.

It is misleading to think that the Universe expanded from a single point. Everything was compressed, including the dimensions of time and space. Until recently, I myself visualized it bursting outward from a point into space—but there was no space as we know it. Space sprang into being; you could say it was "invented" at the same time.

These days, our instruments are fantastic, especially those orbiting in space like the Hubble Space

Telescope. We can see very old light that traveled from the oldest and most distant objects. They are irregular blobs, and galaxies just being formed, 12 billion years ago! The Hubble Space Telescope can take pictures back to only a few years after the Big Bang (about 400,000 light years). Back beyond that, the earliest matter was a dense swarm of elementary particles where our telescopes can't see. It had not yet become hydrogen and helium atoms, which are transparent. Yet even more amazing, nuclear and particle physicists who explore the nuclear reactions in stars, can project back farther, using mathematics to make a model of what the earliest moments of the Universe must have been like. With great difficulty, they can detect and measure telltale particles called neutrinos to test their model. With astonishing accuracy, these measurements confirm their theories.

The theories about those first birth pangs are truly bizarre. Hotter than the core of the Sun, the beginning "point" doubled in size in less than a second—not just the material, but space itself. Suddenly, it inflated

The Holmdel antenna at Bell Labs in New Jersey was originally built to detect radio waves that bounced off Project ECHO balloon satellites. In 1964, radio astronomers Robert Wilson and Arno Penzias found a hissing noise (corresponding to faint radiation) wherever they pointed it. Determined to find the cause, they scrubbed it clean of bird droppings, to no avail. Meanwhile, Robert Dicke in nearby Princeton hoped to confirm a prediction of 3-degree background of cosmic microwave radiation by building a detector. When he learned of the Holmdel hiss, he realized "That's it!" Wilson and Penzias were awarded the 1978 Nobel Prize in physics for detecting the 3-degree reverberation from the Big Bang that proved its existence.[3]

as big as a grapefruit, dense, dense, dense—but not quite uniform— before the rate of inflation slowed down dramatically. Small irregularities caused the hundreds of billions of galaxies to clump into large clusters stretching across unimaginable space, connected by glowing filaments of hydrogen matter. Fortunately for us, inflation has tapered off, leaving us in a rather stable epoch. And the gravity of the Milky Way keeps our Solar System from straying away from it. Galaxies themselves do not expand, because they are gravitationally bound. One endeavor of astronomers today is to scan great sections of the sky and map them.

Physicists expected that as galaxies hurtle away from each other, gravity would gradually slow them down. Mapping the objects farthest from us, they discovered to their amazement in 1998 that very distant objects appear to be accelerating away from each other faster and faster.

Actually it is the space between the objects that is expanding, like two pen marks on a balloon, expanding and moving apart while the balloon is pumped full of air. Cosmologists call the "stuff" that we can't detect and pulls apart space "dark energy." This makes up 68% of the total matter of the Universe.

This is an example of how what we actually observe can spur new theories. With respect to galaxies, including those close to us, another problem was uncovered earlier, in 1933: Stars toward the outside of a galaxy orbit faster around its axis than what is expected by orbital mechanical laws, suggesting that there must be more unseen mass within and around galaxies. This unseen mass is known as "dark matter": We can't detect it but we do observe its effects around galaxies. This makes up another 27%. Which means—what we can directly observe is only 5% of what is really out there!

The mathematics that so ably explains how the inflation of space and matter happened also yields a second result, one that predicts that this might not be the only universe! We simply can't imagine this, or how to prove or disprove it. One thing theoreticians have learned over the years is not to ignore it when there is more than one solution to their math problem, even if it seems crazy. In this way, antimatter, black holes, neutrinos and the Higgs boson were predicted to exist before they were observed. Physicist Max Tegmark writes that many physicists are grudgingly beginning to accept the idea of the "multiverse." "But," he says, "They hate it."[2]

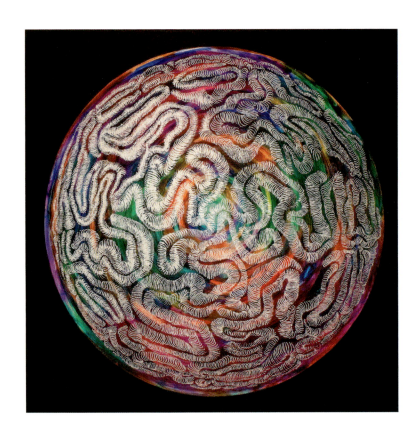

Brain Coral, acrylic on plexiglas incised with white lines, 24" diameter, 1995

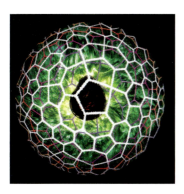

LIFE CREATES
Essential Mysteries in Art and Science

Life Creates is really about two creative forces of life on Earth, creativity of its creatures, and photosynthesis, which has given life a huge boost.

My imagination was arrested by a picture of microscopic filaments of crystals in seawater. The article described how organisms as small as a dot on this page draw minerals out of the seawater to build mineral cages around themselves. To see something at the boundary between the living organism and the nonliving crystals it incorporates charmed me.[1]

A vision came to me of a globe inspired by D'Arcy Thompson's drawing of a radiolarian, a one-celled creature with a glassy shell. That such beauty exists at the microscopic level astonished me![2] Creativity itself! It would be a perfect subject for a round sheet of Plexiglas nearly four feet wide that I acquired for a painting.

Of course, I eliminated the spikes shown in the drawing. It is said that the spikes ward off predators, but also inhibit the organism from sinking into the ooze on the sea floor. This is actually the first painting I did that touched off the whole series.

Later, I learned that in real specimens the crystals are more numerous and smaller than the crystals I have carved in my painting. The struts are stronger than one observes from crystallization that is abiotic, that is, only seawater and silica (silicon oxide) forming itself. Materials scientists, always on the lookout for stronger materials, would like to emulate this.

I wondered, how does the microbe attract molecules of silica dissolved in the water to construct this shell, and why only silica? Why do other microbes like diatoms attract only calcium carbonate? How does the microbe build its ball-like skeleton? D'Arcy Thompson suggests that a foam forms over the microbe, and into the grooves between the bubbles the silica molecules settle. Newer research suggests a

The radiolarian drawing that inspired my painting.

polymer lattice. This still does not explain why other varieties of radiolaria have very different body plans, symmetrical and beautiful. How does their DNA control this? As for the living organism inside, what that looks like I had no idea. I represented it as a soft, dark blob. Now I know that the soft organism oozes around the glass to protect it from being resorbed by the sea. The soft parts can form "pseudopodia," slimy fingerlike projections to capture bits of food. "Little is known about its reproduction." Yes! With the cage around it, one does wonder!

A teaspoon holds a million bacteria. So tiny, yet it is estimated that they account for half the world's biomass. Billions and billions of bacteria and one-celled creatures float in the sea, a zoo of microbes we call plankton, of which the radiolarian is only one. In what Rachel Carson called "the long snowfall," the remains of these small organisms sink to the ocean floor eventually, creating layers of rocks. In the case of radiolaria, they create chert; and those more numerous shells with calcium carbonate form great beds of limestone and chalk.

Spiral rose

Thinking about "life," I chose green for the background, the other subject of my painting.

The first life would have been bacteria, or more ancient tiny microbes known as archea that could survive in hydrogen sulfide and hellish temperatures, the conditions four billion years ago. These extremophiles can still be found at Yellowstone Park in the hot pots, and around undersea volcanic vents. By three billion years ago, evidence in the rocks tells us that a slime of cyanobacteria was covering the seashores, probably green, also red, like today's. An early version of Earth-changing photosynthesis was at work! Photosynthesis captured sunlight with green chlorophyll, and other specialized molecules for capturing light energy. It used carbon dioxide in a complex chemical process to make simple sugars and all the other compounds that comprise the plant. Little factories! Whichever creature incorporated it was freed from scrounging for food. It could make its own. Larger, multi-cellular beings with nuclei, that is, ordinary plants and animals, could become the norm. The one-celled plankton like the radiolarian was the first step of that ladder.

Plant cells and some algae are packed with chloroplasts, thousands of them, full of green chlorophyll and other light-sensitive pigments. Is it any wonder that leaves and forests and slime are green?

Parrot feathers

In photosynthesis, a carbon dioxide molecule supplies carbon for sugars that are manufactured using light energy. At the end of this complicated reaction, two atoms of oxygen are released as one O_2 molecule. Derived from water molecules that were split by light energy, oxygen is "waste product" to the plant. This would prove to be Earth-changing as well. To the world we know today was a rocky climb. Oxygen made the world inflammable, for what else is respiration but burning food for energy?

Most organisms then existing, based on sulfur processes, found oxygen in the atmosphere toxic. They hid, or died. Oxygen accumulated, creating a crisis.

When photosynthesis had nearly used up the carbon dioxide in the atmosphere, a reverse of the greenhouse effect caused freezing temperatures world-wide. Ancient rock strata tell us that glaciers even grew around the equator, and mass extinction followed—a so-called "Snowball Earth" event 850 million years ago. This was discovered in 1987.[3] Another effect was that being very reactive, oxygen changed iron to red rust wherever the two came into contact, which resulted in iron ore and colorful red mountains.

Fossil ammonite shell

But gradually, the organisms that mastered the trick of respiration, using sugar + oxygen for energy, flourished across the globe. It was chemically a more efficient way to live, and enabled living things to become larger and larger. Ozone (O_3) entered the air, too. It formed a protective layer that screened out part of the harmful ultraviolet in solar radiation. Today, the carbon dioxide humans are pouring into the air is nothing at all compared to the "oxygen crisis." It was fortunate that the number of animals increased, and respiration came into balance with the excess oxygen, to give us our stable atmosphere of today.

This much we think we know. A final puzzle: What gives rise to Earth-changing molecules like chlorophyll? Plants and algae also use other molecules that capture light for photosynthesis. Traces of rhodopsin, a pigment key to vision in animal eyes, has existed in algae for eons, to help orient themselves to the sun. And how about red heme, a component of our blood that carries oxygen?

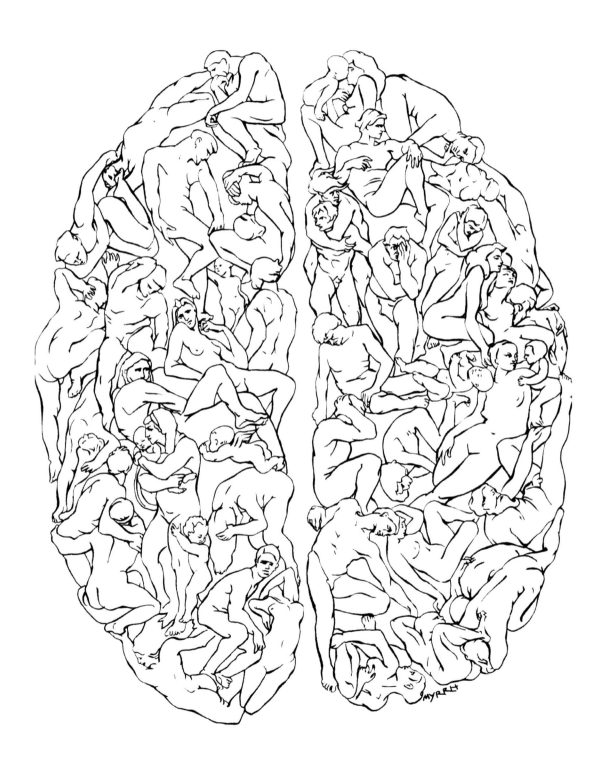

Brains Imagine, Study 1, brush and ink, 15" X 20", 1994

BRAINS IMAGINE
Essential Mysteries in Art and Science

The social animals, dogs and dolphins which run in packs, grew larger brains, the better to keep track not only of prey and their surroundings, but of what each member of their group was up to. These animals play and hunt together, and so do we.

I am especially interested in our ability to mirror what another person is feeling. When the other person cries, our mirror neurons can trigger tears in us. They can help us empathize. Dog owners will tell you that their dogs have it, too! (Curiously, people with autism have trouble doing this.) Humans can vividly *imagine* the details of another's situation, as well.

Cartoon by the author

We use language to tell something that happened, we see it in our mind. But we can use the same language and imaging ability to create novel scenarios. Delighting in stories, we learn to confabulate. Imagine my surprise, when my son Jeff was six, told me they had gone swimming in the playground at recess! True, it had rained so hard they had to wade through the intersection, "But," I said, "Your clothes aren't wet." "Oh, the teacher ironed them!" I remember it, because that was the first time he was able to do this.

We have surplus brain power: daydreaming, restlessly generating plans, rehearsing excuses, and throwing up a flood of colorful scenarios. The brain generates thoughts just as the body generates urine. As anyone who has tried to meditate can tell you, ignoring all this activity is hard! I meditate. I know. On the other hand, I treasure certain dreams, the dynamic stream of abstract visions my art-mind has generated during sex (called synesthesia, when an experience triggers more than one sense), and my freewheeling, inventive thoughts when very relaxed. It's no coincidence that Archimedes ran *from the bath* shouting "Eureka!"

Activating muscles for making a smile can help us change our grey mood. The football player can *visualize* his next move, or feel it in his muscles. Physicist Richard Feynman said he would sometimes roll around on the floor when doing a complex mathematical calculation. Our "brain" is all over our body.

Researchers are actively studying imagination, which involves coordination of several areas of the brain, using MRI scans to image brain activity. Just as the telescope accelerated astronomical and navigational exploration, so MRIs (Magnetic Resonance Imaging), developed in the 1970s and 80s, have revealed the intricate workings of the brain in real time. A lot is now known about the link between the eye, the process of turning what the eye sees into a visual image, and actual recognition. Imagination? As my uncle used to say, that's a horse of a different necktie. How do people juxtapose two ideas, horse and necktie? How do they fantasize other worlds, and so much more? Where can it be detected in a brain scan?

Spontaneously sometimes, out of nowhere comes the great poem, the answer to a large question. No one quite knows what to make of this, but it probably happens in the right hemisphere of the brain, which brings things together holistically. Writing *Messiah* at the peak of his abilities, Handel said it just poured out of him. He himself marveled at this. The right hemisphere has trouble verbalizing about it: The location of most of our verbal abilities is in the left hemisphere.

A sudden experience of illumination, accompanied by feelings of overwhelming love, involve emotional centers deep in the brain. I have experienced this, and the afterglow lasted for a few months. It was life-changing, imparting renewed energy and purpose to my life.

This work, *Brains Imagine*, shows a top view of a brain composed of figures from Western art history. Since the convoluted soft forms of the cerebral cortex readily suggest squirming bodies, it set me to

Tiguey's fountain, Paris (detail), painting by the author

Imaginary guitar

thinking of the multiplicity of personalities and capabilities within. According to Aldous Huxley, the Homeric Greeks did not think of themselves as each having a soul that governed the whole mind, but as being inhabited by various "daemons," each with its own urges. Modern neuropsychology is full of descriptions that suggest this is, in a certain sense, true. It is why willing yourself to stop an addiction is so hard.

I tried to match the activity of the nude figures with the area of the brain in charge of that activity, but it was too difficult! All that remains is Rodin's *Thinker* in the frontal lobe. This is the area of the brain that is noted for planning, ordering activities and imposing values on what to do or not to do—what some would perhaps call conscience.

A rewarding aspect of this work is the interaction with the imagination of you, the viewer. As you do a double-take, you also observe your own brain imagining.

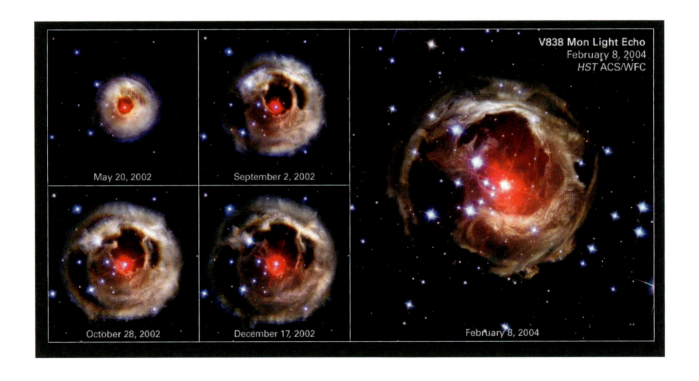

NASA *V838 Mon Light Echo, 2002–2004*

MINDS HAVE WANDERLUST
Essential Mysteries in Art and Science

When I am slowly singing this chant,

> "Ga-te, ga-te, para ga-te, para-sam ga-te, Bo-dhi sva-ha!" Beyond, beyond, very beyond, *beyond* the beyond, Awakening, fulfilled!"[1]

I hear in my mind the age-old sound of it across the Himalayas, those people imagining, as I do, boundlessness of space.

Almost all cultures have ancient creation myths as well. It is our imagination that projects ourselves into deep space and time. The heavens have been our inspiration.

Convinced that the heavens predicted events on Earth, cultures around the world scrutinized the night sky. Which are the earliest? Four thousand years ago we have Stonehenge rocks aligned with the Sun's movements. A similar one, "Earthhenge" dates from 1000 years earlier. But there is more: Some believe ancient stories about the cosmos have been continuously taught in Australia, when settled 40,000 years ago. Paleolithic bone and rock artifacts from the Atlantic to the Russian steppes appear to be tallies of the phases of the Moon. One, the Blanchard Bone, carbon dates to 48,000 years ago.[2]

Two thousand years ago, Chinese astrologers had a government bureau for collecting data (excellent records!) for they believed, as did the Babylonians, that the stars influenced the well-being of the state.

Meanwhile, some Greeks at the beginning of Greece's golden age, were looking at the heavens in a more scientific, geometric way. On May 28th, 2,586 years ago, Thales made the first accurate prediction of a total solar eclipse. Over the next few hundred years, educated Greeks knew the Earth was round, and planets have orbits. They measured the size of the Earth and Sun, as well as precisely measuring the year and precession of the equinoxes. Some genius 2,200 years ago even built a small mechanism with 30 meshing bronze gears, the Anitkythera, for such tasks.[3] Aristarchos of Samos about

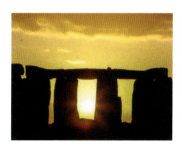

Winter Solstice sunset at Stonehenge in England, which dates from 3000 to 2000 BCE. Cliff markings regarding the solstice dated 8,000 years before Stonehenge have been discovered in South America.

this time conjectured that the Earth revolves around the Sun.[4] However, no one in ancient times had perfect data, and rival ideas also gave good predictions.

By way of Alexander the Great's conquests, the Greeks obtained Babylonian and Egyptian discoveries. Finally, in the year 150 CE, Ptolemy, a Greek living in Egypt, gathered all the sources of data into the 13-volume *Almagest*, pulling all into a single theory that everything revolved around the Earth in perfect circles and spheres. His biggest challenge was that the orbits Mars and Jupiter at certain times appeared to loop backwards. He resolved this by a theory called epicycles, small circles on their large orbits that circled backwards. We give him credit for guessing that the Universe was truly enormous. His calculations worked well enough to be accepted at face value for 1,400 years.

Star formation, 6,000 light years away.

In the Dark Ages of Europe, Arabs were making conquests. In their golden age, they first absorbed the astronomy of India,[5] and about 800, they updated the texts of Ptolemy. With the fall of Constantinople in 1453, the *Almagest* was available in Europe.

In 1543, Copernicus' work proposing that Earth obits the Sun was published. He knew that Aristarchos had believed this. His own work convinced him that only in this way did the observations come into harmony.

Seeing a "new star" in 1572 inspired Tycho Brahe to give his life to measuring stars and planetary motions. The appearance of the supernova punctured the common belief that the heavens were unchanging. His odd notion that the Sun circled the Earth, but Mars and Jupiter circled the Sun didn't hold, but his stunningly accurate observations did. Johannes Kepler, one-time assistant to Brahe, built upon them.

About 1620, Kepler proved Copernicus right. This took two long years. One wrong turn was to idealize the orbits of planets as nesting polyhedra. Plotting out the orbit of Mars, Kepler found it elongated, and realized orbits were not "perfect" circles. Ellipses! Moreover, planets sped up as they were mysteriously drawn toward the Sun. Mathematically, he found a relation between their relative speed and their distance from the Sun.

As on Earth, so with celestial objects. The heavens are not a realm apart, the Sun has spots, Jupiter has moons, the Moon has mountains. This was discovered by Galileo in the early 1600s. The Catholic Church could not handle this variance with church doctrine, and Galileo late in life was confined to house arrest. Einstein wrote: "Knowledge of Reality starts from experience and ends with it. And particularly because [Galileo] drummed it into the scientific world, he is the father of modern physics—indeed, of modern science altogether."

That gravity acts everywhere, not just on falling apples, was Isaac Newton's realization. His contemporaries visualized some kind of force was pulling planets toward the Sun with an inverse square law. Edmund Halley (of Halley's Comet) visited Newton to discuss this, and discovered Newton had already invented the calculus, and worked out the Law of Gravity! It had predictive value: with it, Uranus (1781), Neptune (1846), and Pluto (1930) were discovered.

New tools had a dramatic effect: Newton's reflector telescope made it possible to see fainter, more distant objects. The invention of photography in 1835 captured discoveries. In 1838, Joseph von Fraunhofer invented the spectroscope, and in 1860, Kirchhoff and Bunsen turned the prism in it toward flames, and the Sun. In both cases, the spectrum was marred by dark lines. They could deduce chemical compositions of stars by the pattern of their lines. This could be captured on film. Turning the spectroscope toward starlight, they opened up the marvelous possibility of learning the chemistry of stars.

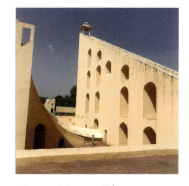

Jantar Mantar Observatory, India, 1734

Harriet Levitt in 1908 devised a way to measure distances to galaxies by finding "standard candles" in them, stars called Cepheid Variables, whose brightness was known.

Astronomy moved into a new phase, astrophysics.

Without these two measurement techniques, Edwin Hubble would never have stumbled upon the red shift. In 1928, Hubble turned his spectroscope toward galaxies whose distance he had measured. On some, the familiar pattern of lines on the prism for known elements had shifted toward the red, some more than others. Why?

A 1931 paper by Abbé Georges-Henri Lemaître compared the known distances to the red shift. Knowing that wavelengths of objects speeding away shift due to the Doppler effect, he could only conclude that these stars were moving away, and that the Universe as a whole was expanding! It was he who first supposed that previously, the Universe must have been smaller, even starting from a single point. This was controversial until 1965, when the 3-degree background radiation from the Big Bang was discovered.

New tools! World War II radar technology made radio telescopes possible. Huge reflector telescopes were built. The space age sent men to the Moon who brought back rock samples. As well, the Hubble Space Telescope, and several that followed, showed the cosmos is full of color and action! Stars in formation, galaxies colliding, remnants of supernovas, jets from black holes, quasars and pulsars ... more has been discovered since 1945 than in all the history before! The newest frontier is dark matter and dark energy.

Space is time and time is space, because light takes time to reach us. We see light from a star or galaxy

as it was *then*. Peering back into 12 billion light years of the distant past, the Hubble shows us a time near the beginning of the Universe: lumpy little galaxies and violent black holes.

In 1970, my physicist husband was reading to me about theoretical objects called dead stars, or black holes, predicted by mathematics.[5] *Invisible?* So I just *had* to make this block print, *Black Hole*, 1973 (p. 38). When he saw it, he said kindly, "Particles rushing inward toward it would heat up and glow, concealing it." Two years later, a barely perceptible shadow in Cygnus X-1 seemed to confirm their existence. It inspired my "ratio" poem.

Penumbra in Cygus X-1	Tomb of the Unknown Soldier
EQUALS	
Numberless Dead Stars	Numberless Souls Lost

"Dead star" is a misnomer, however. Most stars die very slowly without turning into black holes.

Larger observatories and more sensitive satellites are in the works. Increasingly, an astronomer does not have to go to the observatory at a high altitude location in Hawai'i or Chile to observe. Technicians aim the instrument for astronomers who receive their results electronically. They may someday receive their data from an observatory on the Moon![6] Meanwhile, eager amateur astronomers continue to make discoveries.

We have lived through a lot! Our Universe, once confined in our imagination to our Milky Way, has hundreds of millions of galaxies, with a region of dark energy beyond.

"I find it quite beautiful we're part of a solar system and our Solar System part of a galaxy, but our galaxy is part of a cosmic web of galaxy groups, clusters, superclusters, and giant filamentary structures."[7]
 —Max Tegmark, physicist and mapper of galaxies.

"The reward of a young scientist is the emotional thrill of being the first person in the history of the world to see something or understand something. Nothing can compare with that experience."[8]
 —Cecelia Payne-Gaposchkin

"During a space flight, the psyche of each astronaut is reshaped. Having seen the Sun, the stars, and our planet, you become more full of life, softer. You begin to look at all living things with greater trepidation and you begin to be more kind and patient with the people around you. At any rate, this is what happened to me."[9]
 —Boris Volynov, USSR

WHILE MY ART EVOLVED, SO DID SCIENCE
Essential Mysteries in Art and Science

When bumper stickers in the 1950s and 60s proclaimed "Question Authority," I was 10 years older than the hippie generation, when it was protesting and experimenting. I was at home with two babies. But like them, I was skeptical about traditional doctrines. I was a seeker. In my religious life, I sought some kind of personal affirmation of what the Quakers call The Inner Light. Much later, when I was almost 50, I was lucky enough to have a profound experience of it. This brought me one kind of certainty.

I still wondered what was "always true." Sure, I embraced empathy and compassionate action, but beyond that I was skeptical of many religious "truths." I sought some assurance in the material world, which was studied by my physicist husband. I could see a large and interesting relationship between the sciences that attempt to describe our Universe.

I made myself scrapbooks and drawings of natural patterns, noticing mathematical regularities in the objects of the world around us. Especially marvelous and puzzling were those in things like flowers, insects, organs in the human body, and how they could have arisen. Since 1985, methods to explain these regularities in organisms in detail has led to a new discipline, evolutionary developmental biology, or Evo Devo. Its surprising insights show that our previous conception of evolution by random selection isn't so random and improbable after all.

My husband loved to talk about his discipline. In theoretical physics, I marveled that many discoveries had been anticipated by abstract mathematics: the existence of black holes, antimatter, and much more. This imparted a kind of certainty.

As the larger tapestry of the sciences and relation to one another unfolded itself to me, this became the subject of *Essential Mysteries*.

In the first five paintings, I created a journey for my viewers, from abstract mathematics, to the birth of the universe with all its subatomic particles and chemical elements, to life on Earth, to life that could think about itself (consciousness), to life's brain imagining the depths of the Universe. As you can see, each treats a level of matter.

We don't have to think about subatomic particles in order to place an orange on a table. Science historian Jacob Bronowski observed that each represents a level of matter that is distinct. Each has some stable basis on which the next level is built.

Brownowski writes:

> The stable units that compose one level or stratum are the raw material for random encounters which

produce higher configurations, some of which will chance to be stable. So long as there remains a potential of stability which has not become actual, there is no other way for chance to go. Evolution is the climbing of the ladder from simple to complex by steps, each of which is stable in itself.[1]

I found in this ordering of the Universe a consoling certainty. This was my quest. Though one could argue that all of these levels are constructions of our mind, it is not "all in our head," because new things we discover fit into this framework. And this became my mission: to paint about it. But there was more to come. As my art developed its themes, the sciences were evolving, exploring dynamical systems. This would upend how I thought about the world.

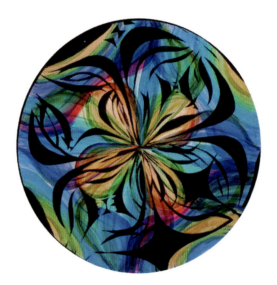

Pastoral Symphony, acrylic painting on both sides of plexiglas, 24" diameter, 1992.

"The most beautiful thing we can experience is the mysterious. It is the fundamental emotion which stands at the cradle of true art and true science—To know that which is impenetrable to us really exists."

—Albert Einstein

COMPLEXITY
Essential Mysteries in Art and Science

I finally noticed that I was painting about boundaries, ones that lie between nothing and something, the inert and the living, brain tissue and thought, thinking for survival and thinking for the sheer joy of it. All these were all examples of *emergence* before I knew the word for it. *Emergence* is a key idea in the new science of Chaos and Complexity.

I had begun in 1992 with levels of matter, and the science disciplines of each. This has certainly enlarged my view of the world. Eleven years into it, I added more mysteries: dynamic subjects like turbulence.

James Gleick's *Chaos: Making a New Science* appeared in 1987, followed in 1992 by M. Mitchell Waldrop's *Complexity*. Colorful images, generated by equations, appeared—strange attractors and colorful fractals. Artists like my friend Ned Kahn at the Exploratorium created intriguing exhibits on the subject.

Several overlapping disciplines change how we can view the world—not so much as single items, but as parts of networks; not so much as nouns, but as verbs. These studies also rattle the cage of certainty. My next four paintings treat chaos and complexity.

Researchers began studying reams of data about how various things emerge: the red spot on Jupiter, the behavior of the economy, weather forecasting, local ecologies, and much more. I was thrilled to watch the first televised fly-by of the Jupiter red spot in 1979 by Voyager I. Still pictures showed the lush colors of Jupiter's atmosphere. Rather astounding were the black-and-white time-lapse movies of it, displaying the surface seething and roiling with circular energy, surrounded by little vortices, also in motion. This revealed that the red spot was like a dynamic but permanent hurricane. Astronomers had not foreseen this. How and why does it persist? They were staggered! More powerful, easier to use computers became available at this time as well, giving us visual models of data, animated ones. I gravitated to these. Science imaging had always fascinated me. The first animation like this I saw was of a dramatic thunderstorm brewed from a single cloud.

The new research goes by several names: complexity, chaos theory, dynamical systems ... its subjects are all around us and in us. It is an octopus of a subject, covering a variety of disciplines—eleven at last count. Melanie Mitchell in *Complexity: A Guided Tour*, writes, "[T]here is not yet a single science of complexity, but several different sciences of Complexity with different notions about what complexity means ... Science often makes progress by inventing new terms to describe incompletely understood phenomena."[1]

Some disciplines that it has touched are: computer science, information theory, atmospheric (weather) science, and more especially in the life sciences: genetics, molecular biology, immunology, neuropsychology, ecology, and evolutionary theory.

Detail of *Intertwingled*
Gestalt, 1999, two layers of 24" diameter acrylic paintings on plexiglas

COMPLEXITY: INTERTWINGLED
Essential Mysteries in Art and Science

Most of us have had to deal with complicated systems. As we thread ourselves through an airport, we may stop to marvel that incoming planes stay clear of each other, even though they approach so closely in the sky that they look like a string of beads. Baggage sorting is an immense operation that goes on largely outside of our awareness. We are in a mass of streaming people, where each of us has to show up at our own flight.

"When we try to pick out anything by itself, we find it hitched to everything else in the Universe."
—John Muir

The biologist E.O. Wilson has written about the legend of the Minotaur:

> The Labyrinth of the real world is ... a ... maze of almost infinite possibility. We can never map it all, never discover and explain everything. But we can hope to travel through the known parts swiftly, from the specific back to the general, and—in resonance with the human spirit—we can go on tracing pathways forever. We can connect threads into broadening webs of explanation, because we have been given the torch and ball of thread.[1]

Intertwined roots

The intricate networking between species is an important study in complexity theory.

Over a period of 30 years, I saw orchards disappear into what became business startups, then skscrapers in Silicon Valley.

Much more distinct and long-lasting was the transition from farming communities to cities. All over the world this happened when the communities reached a certain critical mass, in what are now Turkey, Iraq, Israel, India, China, Central and South America, and even in the American Southwest. We get our word "urban" from Ur, a famous Mesopotamian city mentioned in the Bible.

Like a tropical termite nest 17 feet high in Namibia, these grew of their own accord. Individual decisions

by many separate entities pushed it forward. These systems, like life itself, bootstrapped themselves into complexity. They emerged. Adam Smith in 1776 called it the "invisible hand." Today we say these systems are "self-organizing."

Surely those who began the Internet had no inkling of its complex world-wide, world-changing reach today, or the spinoff effects. An initial condition was set that it would not have a central governing point. In this way, if part of it was destroyed, messages could relay themselves around the damage. It made the system more robust.

This modest initial decision, had it been different, could have created quite a different Internet. One of the realizations of chaos theory is that much of what happens is unpredictable in this way.

Celtic knot pattern

We are accustomed to math predictions that are precise, like the calculations for satellite orbits. For these we use linear equations. Long-term weather prediction turned out to be far more difficult than 19th century science anticipated, however. Most natural phenomena are similar to weather prediction and require sophisticated mathematics such as non-linear equations and complex numbers. Not until the arrival of computers could they be easily studied. You may have heard of the "butterfly effect," where a butterfly flapping its wings in Portugal is said to cause a storm in Moscow a week later. An exaggeration, of course, but a good example of what it's like to make predictions using non-linear equations. A slight change in the input at each iteration can produce vastly different results.[2]

Fritjof Capra, in *The Web of Life*, has a clear explanation of complex (imaginary) numbers, together with a graph, which I summarize here:

> Since the square root of a negative number cannot be placed anywhere on a number line, mathematicians up to the nineteenth century could not ascribe any sense of reality to those quantities ... In the nineteenth century, another mathematical giant, Karl Friedrich Gauss, ... took the bold step of placing them on a perpendicular axis through the point zero ... In this system, all real numbers are placed on the "real axis" and all imaginary numbers on the "imaginary" axis, and given the symbol i ... Gauss created a home not only for imaginary numbers, but all possible combinations of real and imaginary numbers, such as (2+i). ... Many fractal shapes can be generated mathematically by iterative procedures on a complex plane.[3]

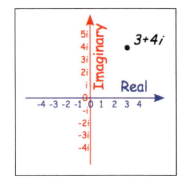

How do you plot a real number 3 with an imaginary number 4i?

On the complex number plane.

"Dynamical systems" was the name Henri Poincaré gave to problems of this type in 1887. He is considered the father of what we now call chaos studies for his exploration of non-linear equations. For example, fractals came to my attention in 1982, with *The Fractal Geometry of Nature* by Benoit Mandelbrot.[4] I and many of my artist friends were bowled over by fractal beauty. A computer equation of the

Mandelbrot set looks so simple. But the same design, repeating endlessly at ever smaller scales, deeply nested, shows feedback at work. The computer image is not static, but zooms in with bright colors to graph the details at multiple iterations. Psychedelic!

A vivid yet simple demonstration of feedback is when you stand between two mirrors that face each other. The reflections, each smaller than the other, seem to go off to infinity. We can say that each reflection is "self-similar." The same thing happens initially when you take a picture of a television screen with a video camera that is connected to the television. But a funny thing happens when you move one of them with respect to the other. The receding images break up, and make crazy, moving patterns. Designs based on feedback-generated self-similarity surprise us with their self-organization.

Mandelbrot said he was showing the "mathematics of roughness." By adding random numbers to fractal-type equations, very natural-looking plants and mountains were generated. Fractals are the secret sauce in computer renderings used to create realistic fur or monster-skin textures.[5]

Computer-generated fractal

In the real world, these charming irregularities do not develop in isolation. The larger system has its influence on initial conditions, so that each growing snowflake, each ocean wave, each leaf, each lightning flash is different. Often, artists and musicians create fractal layers of beauty in their own work. They have always felt at home with this view of nature!

"Intertwingled" was a word coined by computer guru Theodore Nelson, one of the first to envision linked information on the Internet. It was jealousy of computer images that caused me to hand-paint *Intertwingled*, an invention of my own making.

Chaotic complex systems are much broader than this. Weather sensors, economic data, and disease epidemics yielded reams of data that could now be fed into computers, and surprises were in store: In some cases, strikingly different systems were mathematically similar.

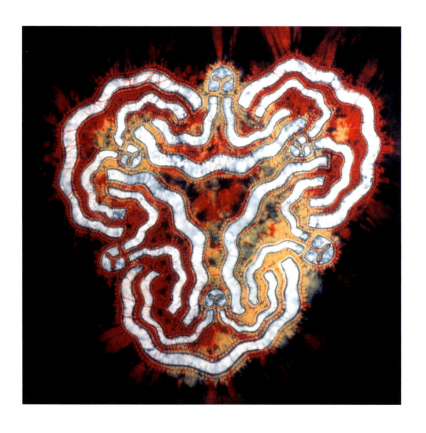

Artist in Resonance, batik banner with shibori (Japanese stitched tie-dye), 45" wide, 1977

COMPLEXITY: SYNCHRONY PREVAILS
Essential Mysteries in Art and Science

Intertwingled doesn't really capture the intergrated systems in simultaneous motion that everything depends on. All modes of transport and communication, whether in your blood system, the environment, or man-made systems like the power grid and the Internet all operate largely outside of our awareness, all in motion day after day, night after night, by and large flawlessly.

An example close to home that captivates me is how our cells turn food into energy. The pathway from absorbing the food to burning the calories for energy requires a bewildering number of chemical reactions. These must be performed in exact sequence, continuously. Inside each cell, mitochondria each have a maze of membranes studded with a host of minute particles sticking to them. Each particle has several enzymes, biological catalysts that speed the reactions that break down and reconfigure compounds. (Catalysts are like the platinum in the catalytic converter of your car: They take part in a chemical reaction without themselves becoming used up). The number of reactions, and their speed is truly unbelievable! The intricate diagram of just one of these chemical pathways, the citric acid cycle, would fill this entire page.[1]

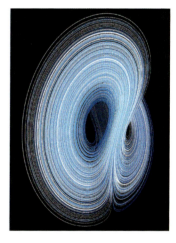

Lorenz strange attractor

Curiously, the mitochondria started out as invaders. This is seen by their DNA, which is like that of bacteria from a completely different branch of the "family tree of life." Early in the evolution of eukaryotic cells, (those of animals and other familiar life forms) which have a nucleus, back when these were far simpler, the mitochondria became stowaways. They provided a useful service and stayed.[2] Inside the free-living eukaryotes, they still grow and divide by themselves. The jaw-dropping fact is that each cell contains between 10 and 1,000 of these tiny non-stop factories!

Emergence goes beyond the definition of *gestalt*, the idea that the whole is greater than the sum of its parts. Its parts grow and change in relation to each other.

It is developmental, reorienting our basic view of the origins of stars, mountains, and of life itself. This

view doesn't include a Great Designer. Strangely, I have found this expressed best by an ancient Chinese quote, for this sensibility has been around for a long time:

> The harmonious cooperation of all beings arose
> not from the orders of a superior authority external to themselves,
> but from the fact that they were all parts in a hierarchy of wholes forming a cosmic pattern,
> and what they obeyed were the internal dictates of their own nature
> —Chung Tzu, 3rd century

Oak silhouette

This sounds like a recipe for anarchy! It would be, except a dynamical system is a bounded system, in the same way that an oak tree, however tormented its twisting branches, has an overall contour as regular as a head of broccoli. Dynamical systems do have boundaries!

Another example: We often see a computer-generated diagram of a Strange Attractor like that on the previous page in writings about dynamical systems. It is Edward Lorenz' simplified model for plotting variables. Composed of many individual lines that each plot the same equation over and over, using different inputs, the lines are grouped. They don't fly off into space. You might say they are quasi-predictable. Like history, as Mark Twain said, they "don't repeat, but they rhyme." This is what we mean by having a boundary.[3]

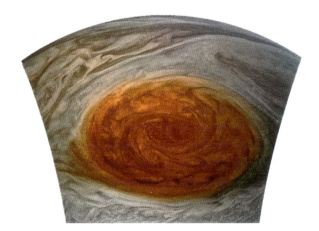

Painting of Jupiter's red spot

There are many, many examples of a bounded system. Examples include: ethnic traditions preserved even when transplanted in another country; life in a tide pool; and on the molecular level, the patterns in marbled paper.

Marbled paper is often found on the flyleaves of antique books. It is a simple craft that yields magical results. Since I have done this craft, I can explain it. Drops of diluted pigment are dropped onto a special watery medium, one cohesive enough to keep the paint from sinking.

Instead of sinking, the drops spread out widely to a few molecules in thickness. Each drop maintains its integrity, even when stretched. This is owing to the fact that each molecule of paint is "holding hands" on all sides with its neighbors, but the molecules on the edge have none to "hold onto" except each other, which creates an especially strong bond. This is due to the "hydophobic effect."[4]

Stirring the floating paint, working with it to achieve surprising results, was my way of participating in complexity.

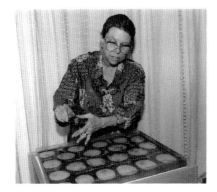 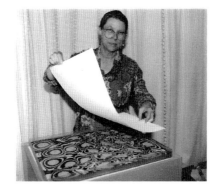 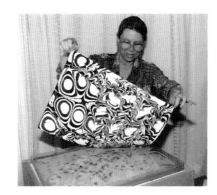

The author does paper marbling, laying the paper
on floating paint and removing it.

Veil of Veronica, 8" x 10" pen and ink, 1958

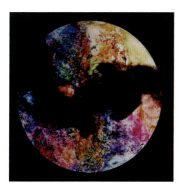

COMPLEXITY: DEATH TEEMS WITH LIFE
Essential Mysteries in Art and Science

Biologist Lynn Margulis tells us:

> This is a difficult lesson: the matter of our bodies, our possession, our wealth is not ours. It belongs to Earth, the biosphere and, whether we like it or not, that is where it is headed, again and again.[1]

Like a human pyramid, "stuff" we see in the world, with few exceptions all bear the fate of impermanence, though some things maintain their appearance better than others.

The Buddhists teach, "all is impermanence," like the jiggly arrangement of a human pyramid. Since I am the daughter of a geologist, I tend to take the long view, in millions and billions of years. Since Darwin, we understand everything evolves.

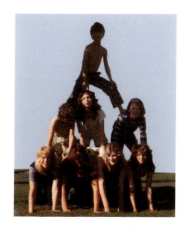

Human pyramid

> No longer do we think atoms are solid, species, mountains, continents,
> stars are fixed or the universe unchanging;
> Atoms change to new elements;
> Genes mutate and create small changes to offspring;
> Creatures evolve as some die out and new types appear;
> Societies change even within our own lifetimes;
> Mountains rise and fall as Earth's crust deforms and erodes;
> Continents drift, pushed apart by sea-floor spreading;
> Stars evolve, being born, changing, dying;
> The Universe expands from a hot mass to billions of galaxies;
> "Evolution" itself evolves as the theory itself is elaborated by new discoveries.[2]

We avoid thinking about the end of our life, but we should be thinking about the beginning of new

life, beginning with decomposers like maggots and fungi living off what is left. After a forest fire, seeds especially equipped to germinate when stimulated by intense heat, spring into action.

I am learning more about decomposing microorganisms. Bacteria are one-celled, but the one-celled Dictyostelia, which feed on plant materials, are chummy. When food is scanty, they sense when food is scarce, clump together as a group and create a "pseudoplasmodia." That is, it becomes an oozing mass of rolling jello to a new site. Finding none, the group bunches tighter, growing a stalk. (It resembles strange "cymatic" forms in magnetic filings when the filings are vibrated with sound waves.) The lucky ones on top of the stack become spores to travel on air. They find greener pastures, or hibernate.[3]

How do we define conscious behavior?, If the cells have a sense of "we," as "We're all in this together," if the group makes decisions about moving forward, what is consciousness? Inanimate rocks don't do this. How does this change human philosophies?

Philosophers and physiologists have discussed whether "mind" is a phantom arising from the brain, or inherent in its cells. For millenia, religions have affirmed the belief in an immortal soul. Aztecs believed that you are born with your death. It is your bones, which grow with your life and outlive you.[4]

Animal bone fragment

Fungi decomposing wood

After a fire, regrowth!

Perceptions, thoughts, and feelings seem to be tied up in a unified package we call our mind, that it is an activity of the connections between cells. Our "brain," our way of knowing the world, is not only in our skull. It is distributed all over our body, in our nervous system, in our hormones, and more. Each portion of the brain has a version of it, which is why, when damage disables part of the brain, the consciousness remains. I see this consciousness in my devastated husband who has Alzheimer's.[5] Yet this can be erased in an instant by a poison gas.

This would seem to point to the idea that our being—personality or soul or whatever you may call it—is

in the connections between the cells in our body, and these connections are shattered at death. It is not only our body, but in our connections to others, like roots in the redwood forest connecting many trees. The penumbra of presence of the departed can be vivid.

Is this all? We sentient beings resist this. We mourn for those vivacious spirits mowed down by disease or cruelty or war, especially if they were young. We wish for these connections to exist intact in the beyond. Coal miners labor on, lifted up by their vision of the bright hereafter. People suffering under extreme cruelty hope for ultimate justice.

The experience I had of light and love in 1979 can strike anyone anywhere, even in the most desperate situations. It briefly feels like a veil has been lifted, a oneness with all. Afterwards, I made a Klein bottle, a curious shape where the inside is the same as its outside, to express this feeling. I felt embraced by hope. That spark of hope has kept many people alive.

Over the years, a small set of uncanny experiences I have had has suggested to me that there is more behind the veil of materialist thinking, such as something that Elisabeth Kübler-Ross said in 1969 when being interviewed about her book, *On Death and Dying*. It stuck with me. She described how a close friend died, and a little while later in the middle of winter, she saw by her window a single, large magnolia bloom. It seemed to be like a message from her friend.[6]

Here is my most recent experience. It seemed beyond belief to my materialist mind. Yet it happened to me in 2015, after my black storyteller friend, Orunamamu, died a thousand miles away in Canada. To excite children's curiosity, she used to declare, "Have you noticed that everywhere that you go there are birds? And if you see a little feather, a soft and tickly feather, it's for you! Pick it up, put it in your pocket. A feather ... is a letter ... from a bird!" Shortly after she died, while parking my bicycle at the Quaker meeting we attended together, I found an unusual large, fluffy, white feather right by the bike rack where I usually parked. I saved it. As this essay demonstrates, I am not convinced there is an afterlife. But, as if to quell my disbelief, an almost identical one landed in the same place a week later.

It is unknowable, unprovable, the ultimate mystery.

Surge, monoprint on cloth, 16" X 24", 1977
Our Heads Above Water, block print, 20" X 20", 1971

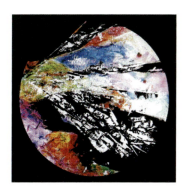

COMPLEXITY: CATASTROPHE!
Essential Mysteries in Art and Science

Stuart Kauffman, researcher at the Santa Fe Institute, has written:

> Thirty years of research have convinced me that [evolution by random selection, the dominant view in biology] is incomplete. Another source—self-organization—is the root source of order. The order of the biological world, I have come to believe, is unpredictable [or novelty-producing] in this way.[1]

An amazing example of self-organization is African termites that "move a fourth of a metric ton of dirt to build mounds that can reach 17 feet (5 meters) and higher." They have "indoor gardens" for their food, fungi. "This is a system where complexity is of the essence, 'If you don't capture the complexity, there's no hope of understanding it.' And so the quest continues for the elusive mind in the mound."[2]

On a *Nova* program, physicist Philip Morrison once told how termites begin the nest: Several termite nests begin in a circle. Each grows quite tall. At a certain height, they begin to build inward until they meet to make one spire.

Emergent systems are bounded. Nevertheless, they are loose enough to adapt, to innovate, to fix shortcomings. If I knew more, I could pick a good example from the biological world, like the develoment of the eye. But let us take airplane design, with its severe problem of staying in the air. The aerodynamics of a plane passing through the air is well enough understood to streamline the shape, and to design motors with enough thrust. That is the bounding condition.

The design changes that have taken place over 100 years are remarkable. They have consisted of correcting safety defects (a checklist "written in blood" says the pilot), allowing airplanes to do more (carrying hundreds of passengers), and to use the materials more economically. These have made the design more robust. At the same time, each "fix" has added its own weaknesses. In that sense, it becomes more fragile. Yet it works! It's a marvel prone nevertheless to rare catastrophic failure. It

Crab Nebula—an explosion in space

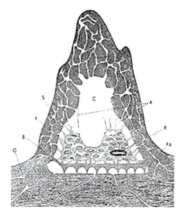

African termite nest 25 feet tall

has reached a state of criticality, poised between success and failure. Very many of our systems are composed of a vast number of interlinked parts that may interact in totally unforeseen ways. This is a new kind of accident that Yale professor Charles Perrow calls "normal accidents" where no one person is to blame. They are somewhat rare, but like the tsunami and nuclear reactor meltdown at Fukushima, Japan in 2011, utterly devastating.[3]

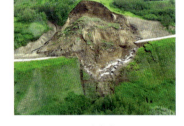

Mudslide

In the physical world, researchers have studied the tipping point between stability and catastrophic failure by making detailed measurements on, of all things, sand piles. Dropping one grain at a time, they note the unpredictable point at which only one additional grain will start an avalanche—the straw that breaks the camel's back. Similarly, trivial events like a tree falling on wires can take down the power grid locally, then that power failure cascades into huge ones across whole states. The organization of a system, whether with earthquakes, forest fires, or market crashes, makes it "possible for a small shock to trigger a response that is all out of proportion to itself. It is as if these systems had been poised at some knife edge of instability, merely waiting to be 'set off'."[4]

Not that this is an altogether bad thing!

Many systems are "poised at the edge of chaos." The edge of chaos is like the continental edge, far out on the continental shelf where nutrients from the land meet the upwelling from the ocean deep. The mix of ingredients creates new combinations. Too close to land, not enough variety. Off the edge, into the ocean deep, the ingredients are too dispersed to interact well. But this "sweet spot" is one of great biological creativity, a nursery for evolution.

Domino Effect

Chris Langdon, an artificial life programmer, says he had an insight while scuba diving in Puerto Rico, while comparing the dives close to shore, with its clear water, to 2,000 feet further out, in "that enormous fluid nursery [of life]." This gave him "this irresistible vision of life as eternally trying to keep its balance on the edge of chaos, almost in danger of falling into too much order on the one side, and too much chaos on the other."[5]

Some folks live their lives taking risks, undertaking more than the rest of us, never bored. Small town life is not for them! Too little novelty, not enough grist to innovate. But neither do they do their best work in a war zone. Too much anarchy. Cities provide them the needed stimulation. They find life at the edge of chaos a world of exciting motion! It takes constant small adjustments to keep one's balance. To a certain extent, I am like that, and among my artist friends, I know dozens of others.

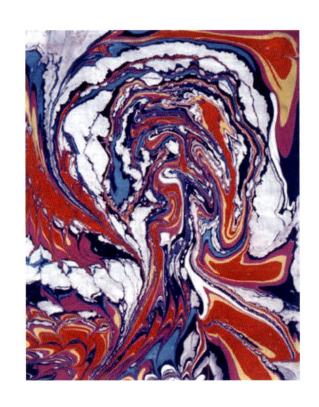

Mushroom Cloud Head, marbling on cloth, 8" X 10", 1990

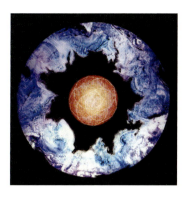

TURBULENCE
Essential Mysteries in Art and Science

One bell tone sounds, clear and pure. Then another, slightly out of tune. This produces an unexpected warble, a curious oscillation between them. If gong-like bells are struck at the same time, sounding four or five different notes, the reverberations echo, blend, and waver, leaving the room awash in sound.

Similarly, a sheet of water runs over smooth rock, a simple laminar flow. Faster it goes, perhaps around an obstacle like a bridge support. As we look over the bridge we see it break into two swirls, alternating back and forth, pretty oscillations. Calculus can be used to describe them.[1]

Faster it goes, breaking into so many small eddies, each with its own path, that defies description. Mesmerizing! This is turbulence. I have been taking pictures of rapids and whitewater ever since I got my first little Brownie camera at the age of twelve.

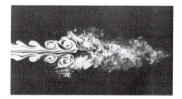

Turbulence

Blood flowing through arteries, encountering friction from artery walls, has turbulences that cause a characteristic "bruit" or noise that doctors listen for with their stethescopes. Arteries narrowed by cardiac problems make a different sound.

Cigarettes are smelly, addictive, and bad for health. But one of my pleasurable memories was of watching the smoke of my mother's cigarette rise, catching the early morning sun. It starts with laminar flow, then it quickly becomes turbulent as it encounters the cooler air around it. It lazily curls around in the warm updraft into randomly pleasing swirls.

Suspended smoke particles, all particles not quite visible to the naked eye, are in constant motion. Brownian motion is purely random motion of them, never ceasing, visible through a microscope. In 1905, Einstein explained based on statistical mechanics, why a smoke particle would constantly wobble back and forth. It was the random difference between the pressure of molecular bombardments coming from different directions in three-dimensional space. What causes the bombardment? Constantly moving particles that are smaller: atoms and molecules of air.[2]

This was instrumental in ending the debate about whether atoms and molecules were merely theoretical, or actual physical entities. A bit weird to us now that this was ever in doubt!

Nevertheless, turbulence still puzzles physicists, involving as it does nonlinear equations. Richard Feynman and others regard it as the last unsolved problem in classical physics. Its self-similar eddies at smaller and smaller scales are hallmarks of what we often see now in complexity theory.

Laser light interference

Melanie Mitchell writes, "There was a story about the quantum theorist Werner Heisenberg on his deathbed, declaring that he will have two questions for God: why relativity, and why turbulence? Heisenberg said, 'I really think he might have an answer to the first question.'"[3]

All my life I have been fascinated with water, and defeated in my efforts to paint it. Starting a new painting with the idea of creating a smooth blue border, I poured the blue paint onto my horizontal round plank of plexiglas, and covered it with pieces of plastic film. When I pulled them up, surprise! Not smooth! Turbulence! Instead, I had created this marvelous effect. I knew better than to "improve" it, and there it lay for several years. Then, I was able to "go with the flow" in the creative process. The geometric design in the center of the painting represents our meager tool for describing turbulence.

Whitewater

Tissue Emerges (detail of *Emergence*)

EMERGENCE
Essential Mysteries in Art and Science

The idea that the whole is greater than sum of its parts is called *gestalt*. Emergence is more than this. The individual parts grow and change in relation to each other. To understand this enables us to better grasp brain function, ecosystems, the weather, and the growth of cities.

Emergence helps us understand how evolution was at work even before there were living organisms.

One essential mystery is how life began. On the early Earth, conditions were right for the formation of essential chemical building blocks of life as we know it today. Over long periods of time, larger and more complex molecules, in greater variety accumulated in seawater. Eventually, elaborate chemical processes began to occur, similar to metabolic pathways in living organisms, described as an emergent property by Stuart Kauffman, researcher at the Institute for Systems Biology.[1]

Bacterial colonies

One molecule that formed long chains and the ability to replicate itself was ribonucleic acid, or RNA (similar to DNA, which came later). In modern organisms, RNA does most of the work of translating the code from DNA into amino acids linked together in the right sequence to make all the protein molecules for cells to function. Many other roles of RNA in regulating this process of gene expression have recently come to light and are still under investigation.

Among all the protein molecules that make living things work, we see countless examples of similar proteins with dissimilar functions. For example, the enzyme that causes mushrooms and avocados to darken in the presence of oxygen is very similar to the blue proteins that carry oxygen in marine invertebrates. Hemoglobin, the protein that carries oxygen and makes our blood red, also occurs in microorganisms (slightly different variants of it), playing roles such as protecting them from oxygen damage.

Such interactions obey the laws of physics and chemistry, but these laws cannot alone predict their occurrence. These happenings are unpredictable. This gives evolution an element of creativity, beyond

blind chance.² These illustrate "the adjacent possible," combining unalike things to make a new capability.

Here's an example of the adjacent possible: combining steel-reinforced concrete buildings with the invention of safer elevators made skyscrapers possible. Invented in the 1850s, they both made the Manhattan building boom in the 1920s begin to shoot vertically into a forest of skyscrapers. To approach that tiny landmass by sea is truly an amazing sight. Back in 1920, it would have been inconceivable.

Stuart Kauffman has written:

> The past three centuries of science have been predominantly reductionist, attempting to break complex systems into simple parts ... But it has often left a vacuum: How do we use the information gleaned about the parts to build up a theory of the whole? ... The complex whole may exhibit properties that are not readily explained by understanding the parts. The complex whole in a completely non-mystical sense can often exhibit collective properties, 'emergent' features that are lawful in their own right.³

The edges of my painting, *Emergence*, represent a sea of possibilities. Where they meet and coalesce into a "tissue," that magical, unforseen moment is represented by its lacy interior.

A baby emerges

ALBERT EINSTEIN

"People like you and I, though mortal of course, like everyone else, do not grow old, no matter how long we live. What I mean is we never cease to stand like curious children before the great Mystery into which we are born."

Einstein, 1995, acrylic painting on clear acrylic plastic sheet 3/16" thick, lines engraved with a rotary power tool, 45" diameter.

AFTERWORD

Physicist Werner Heisenberg whose Uncertainty Principle summed up the limits of what we can observe in the realm of the very small wrote:

"In science, we realize more and more that our understanding of nature cannot begin with some definite cognition, that it cannot be built on such a rock-like foundation, but that all cognition is, so to speak, suspended over an infinite abyss."[1]

++++

Science is System Searching for System, 1971, block print 20" X 30", edition 6 (one in blue)

BIBLIOGRAPHY and ARTIST'S NOTES
Essential Mysteries in Art and Science

THE WORLD OF SMALL AND LARGE

1. Garrett Hardin, *Biology: Its Principles and Implications*, 2nd Ed. (San Francisco: W.H. Freeman, 1966). For beginning students, Hardin began with a succinct overview of the major sciences, and how they composed a unified system.

2. J. D. Watson and F.H. Crick, "Molecular Structure of Nucleic Acid," Nature April 1951, pp. 737-38

3. Frank R. Wilson, *The Hand* (New York, Random House 1998) p. 171.

4. phys.org/news/2009-06-prehistoric-flute-germany-oldest.html

 Also, Fritjof Capra, *The Web of Life* (New York: Anchor Books, 1996), p. 263, "Only humans paint, only people plan expeditions to the rear ends of damp, dark caves in ceremony. Only people bury their dead in pomp. The search for the historical ancestor of man is the search for the story-teller and the artist."

5. Joel E. Primack and Nancy Ellen Abrams, *The View from the Center of the Universe* (New York: Riverhead Books, 2006), "The size of a human being is at the center of all the possible sizes in the Universe," p. 158. Diagram, p. 160, shows the smallest, 10^{-25} cm and largest, 10^{25} cm.

6. Maria Montessori, *To Educate the Human Potential*, Chapter 1, "The Six-Year-Old Confronted with the Cosmic Plan" (Kalakshetra Publications, 1948, abridged 1985).

Suggested Reading

- Ernst Haeckel, *Art Forms in Nature*, (New York: Dover, orig. pub. 1913).
- Gyorgy Kepes, *The New Landscape* (Chicago: Paul Theobold & Co., 1956)
- Lynda Obst, ed., *The Sixties* (New York: Random House/Rolling Stone, 1977) p. 168, "Why Haven't We Seen the Whole Earth from Space?" by Stewart Brand.
- Theodor Schwenk, *Sensitive Chaos* (London: Rudolf Steiner Press 1965).

Artist's Note:

All the paintings in this series are painted on 45" rounds of 3/16" thick plexiglas. To give a "tooth" for the transparent acrylic colors to adhere, the whole surface was sanded. The white lines were cut through the layer of color with an electric tool.

NUMBER GOVERNS FORM

1. *Communications on Pure and Applied Mathematics*, vol. 134.

2. Gyorgy Doczi, *The Power of Limits: Proportional Harmonies in Nature, Art, and Architecture*

(Boulder, CO: Shambala, 1981), p. 82. The Fibonacci sequence can be generated by any child: 1+1=2, 2+1=3, 3+2=5 and so on. The mathematician Fibonacci (1175–c.1250) popularized the Hindu–Arabic numeral system in Europe that we now use for arithmetic, and introduced to Europe this sequence of numbers.

3. Fred Hoyle, *Astronomy* (New York, Doubleday, 1962), p. 10.

4. Michael Hudson, *An Enquiring Mind: Studies in Honor of Alexander Marshack* (America School of Prehistoric Research Monograph Series, Oxford and Oakville: Oxbow Books, 2009), p. 150.

 In his 1972 article on the "Blanchard Bone" lunar notations c.28,000 BCE, he postulated a worldview extending from the Atlantic to the Russian plain:

 > Long-distance movements and a dispersal of cultural influences were clearly present during this [Magdalenian] period ... Paleolithic calendar keeping was pre-mathematical, predating actual arithmetic in the sense of counting in the abstract. ... But it was the matrix out of which counting systems developed, inasmuch as the first phenomena to be counted seem to have been the rhythms of the moon and sun, not one's fingers. The key number 28, for instance, evidently was derived from the days of visibility in the lunar month, to which Alex attributed the prominent role of the number 7 as its divisor.

5. Sean B. Carroll, *Endless Forms Most Beautiful: The New Science of Evo Devo* (New York: Norton & Co., 2005).

6. Max Tegmark, *Our Mathematical Universe: The Quest for Ultimate Reality* (New York: Borzoi Books, 2014), p. 6.

 Note: This "Platonic" view is under debate. In at least some areas of investigation, results are imprecise and statistical. This view posits that mathematics is a human construction that just happens to fit some phenomena that are orderly. Perhaps others aren't. See the *Nova* program, www.pbs.org/wgbh/nova/video/the-great-math-mystery.

7. Tegmark, p. 183.

8. Rudy Rucker, *The Lifebox, the Seashell, and the Soul: What Gnarly Computation Taught Me About Ultimate Reality, the Meaning of Life, and How to be Happy* (New York: Thunder's Mouth Press, 2005), p. 5.

9. Jacob Bronowski, *The Ascent of Man* (Boston: Little, Brown & Co. 1973), p. 95.

10. June Wayne, private conversation.

Artist's Note:

In *Number Governs Form*, the crystals were engraved in the plastic with an electric tool. The whole surface of it had been sanded to a matte finish, but when I polished the front face of each "crystal" like my specimen, it suddenly looked "real."

ENERGY BECOMES MATTER

Except where otherwise noted, the information comes from Max Tegmark, *Our Mathematical Universe* (New York: Alfred A, Knopf, 2014), p. 56.

1. Philip Gibbs,1997, www.math.ucr.edu/home/baez/physics/Relativity/GR/centre.html.

2. Max Tegmark, *Our Mathematical Universe* (New York, Alfred A. Knopf, 2014).

3. *APS News* (American Physical Society), July 2002, vol. 11, #7, June 1963: "Discovery of the Cosmic Microwave Background."

Other Sources:

- Neil de Grasse Tyson, *Origins* (New York: W.W. Norton, 2004).
- www.physicsoftheuniverse.com/topics_bigbang_expanding.html (Retrieved 2016).

Artist's Note:

The design for *Energy Becomes Matter* is based on mud cracks. To make the powerful three-dimensional effect, it was very easy to hand-draw the cracks, making large units in the center, and gradually diminishing them toward the edge. Before painting them, I had to create the red background. Even with an airbrush, this was not easy. Some paint hardened before it hit the surface, some emerged in blobs.

LIFE CREATES

Except where otherwise noted, the information comes from Lynn Margulis and Dorion Sagan, *What is Life?*, (London: Weidenfeld and Nicholson, Ltd, 1995).

1. Shinya Inoue and Kayo Okazaki, "Biocrystals," *Scientific American*, April 1977, pp. 82-4.

2. D'Arcy Thompson, *On Growth and Form* (London: Cambridge University Press, 1961) p. 160.

3. Peter Ward and Joe Kirschrink, *A New History of Life* (London: Bloomsbury Press, 2015), pp. 80-9.

Artist's Note:

In *Life Creates*, first came translucent green paint the consistency of finger paint, which I pushed around with my hand. Then came the black "living cell" (my conception). Superimposed over it was my drawing of the silicate "cage" based on the science illustration, where I subtracted the green paint down to the

clear plastic. Finally, I used my small electric tool to dig into the plastic to simulate crystals, which glitter in the light. The last step took weeks.

BRAINS IMAGINE

Imagination is an area of active research using MRI and other imaging devices. Two researchers are: Randy Buckner at Harvard, and Stefania Ashby at University of Oregon. Ashby writes: "Remembering and imagining differentially engage the hippocampus."

Suggested books:

- Rita Carter, Susan Aldridge, Martyn Page and Steven Parker, *The Human Brain Book* (London, DK Books, 2009). A comprehensive and understandable reference, made easier by many color illustrations.

- Jon Kabat-Zinn, PhD, *Full Catastrophe Living* (New York: Delta Books, 1990). A book of meditation practices based on the Stress Reduction Clinic at the Massachusetts Medical Center. A useful study guide that engages us with interesting case histories.

- Rick Hanson, Ph.D. His short talks are at www.rickhanson.net/. Negative events embed themselves more than positive ones, a survival mechanism. If we especially notice the good ones, it can improve our outlook on life.

- Ellen J. Langer, *On Becoming an Artist* (New York: Ballantine Books, 2005). Her psychology experiments with people show how our imagination, "Oh, I'm not creative," or "It's just that I'm getting old" shapes how we move in the world. These can be overcome.

- Robert M. Sapolsky, *Behave: The Biology of Humans at our Best and Worst* (New York: Penguin, 2017). This 700-page study probes angry impulses in all different dimensions: from the neurobiology of dismay, to one's upbringing, to its culture, and what influenced the cultural formation.

- Richard Restak, MD and Scott Kim, *The Surprising Science of How Puzzles Improve your Mind* (New York, Riverhead Books, division of Penguin, 2010). Restak, a researcher in neuroplasticity, identified a dozen useful cognitive functions that improve with practice. Scott Kim designed puzzles for each for practice.

Artist's Note:

In *Brains Imagine*, painting human bodies on plexiglas presented a new challnge. Having decided to use classical figures for my "brain," the first project was how to gather examples and make them compatible in size. When I photocopied them from art books, I made the size of the copies all have the same head size. You notice that Rodin, Michaelangelo and Rubens provided the best figures. Then I cut them out and arranged them on a piece of paper the size of my painting-to-be. What a puzzle! After making

two small ink studies of them, I began to paint. The shadow on each copy varied, but in my painting, they all had to have the light appear to come from the upper left to look like the same object, another layer of difficulty.

MINDS HAVE WANDERLUST

Except where noted, my reference has been *The History of Astronomy*, Heather Couper and Nigel Henbest (Richmond Hill, Ontario, Canada: Firefly Books Ltd., 2007).

1. Sanskrit chant (hyphens added), *Heart Sutra*. (Translations of the Sanskrit vary. I first learned of this in a 1956 lecture by Aldous Huxley).

2. Michael Hudson, *An Enquiring Mind: Studies in Honor of Alexander Marshack* (American School of Prehistoric Research Monograph Series, Oxford and Oakville: Oxbow Books, 2009), p. 150.

3. Jo Marchant "Decoding the Antikythera Mechanism, the First Computer," (*Smithsonian Magazine*, February 2015).

4. Fred Hoyle, *Astronomy* (New York: Doubleday, 1962), p. 94.

5. In 1939, physicist J. Robert Oppenheimer and his student George M. Volkoff published a scientific paper predicting the existence of superdense stars that would have extremely deep, perhaps even bottomless, gravity wells. In 1967, Physicist John A. Wheeler coined the term "Black Hole."

6. Max Tegmark, *Our Mathematical Universe* (New York: Alfred A. Knopf, 2014), p. 82.

7. Ibid.

8. Cecelia Payne-Gaposchkin and Kevin Kelley, *History of Astronomy* (Menlo Park, CA, Addison Wesley; Moscow: Mir Publishers,1988) Image #89: Boris Volynov, USSR.

Artist's Note:

In Minds Have Wanderlust, I tried several studies to suggest outer space, but the effect was dark and boring! Sifting through many Hubble images, I chose this one for its "embrace" and drama. Hardest was to make my drawing capture the sweeping fluid-flow action, amazingly similar to fluids and clouds on Earth. I changed the color, because the brown of the original came out looking like earthly mud. The star placements are my own, their sparkle drawn with a cutting tool through the black paint.

WHILE MY ART EVOLVED, SO DID SCIENCE

1. Jacob Bronowski, *The Ascent of Man* (Boston: Little Brown & Co. 1973), p. 348.

COMPLEXITY

1. Melanie Mitchell, *Complexity: A Guided Tour* (Oxford: Oxford University Press, 2009).

Suggested Reading:

- James Gleick, *Chaos* (New York: Penguin, 1987).
- M. Mitchell Waldrop, *Complexity: The Emerging Science at the Edge of Order and Chaos* (New York: Simon and Schuster, 1992).

COMPLEXITY: INTERTWINGLED

1. Edward O. Wilson, *Consilience: The Unity of Knowledge* (New York: Vintage Press, 1999), p. 67.

2. Fritjof Capra, *The Web of Life* (New York: Anchor Books, 1996), pp. 122-3.

3. ibid., pp. 143-5.

4. Benoit Mandelbrot, *The Fractal Geometry of Nature* (New York: Times Books, 1982).

5. In the brochure for his first book from W.H. Freeman in San Francisco, Mandelbrot described it as the "mathematics of wiggles," which is more picturesque.

Artist's Note:

In *Intertwingled*, I drew an exquisitely detailed maze and had it enlarged. On a light table, I lay the plexiglas circle on top of it to trace it, playing with the colors. It was delicate handwork all the way.

COMPLEXITY: SYNCHRONY PREVAILS

1. Claude A. Welch et al., *Biological Science: Molecules to Man* (Boston: Houghton Mifflin, 1972).

2. Cynthia Needham et al., *Intimate Strangers: Unseen Life on Earth* (Washington, DC: ASM Press, 2000).

3. www.chaosmath.org. To see a great YouTube of the Lorenz Attractor in motion, www.youtube.com/watch?v=aAJkLh76QnM.

4. Kennan Salerno, www.reimaginingscience.org, remarks that in paper marbling "The hydrophobic effect is beautiful unto itself. Molecules maintain hydrogen bonds (the 'holding hands') to minimize chaos in the surrounding water, such that each has a maximum number of organizing interactions within itself. Disruption is minimized. It's a beautiful thing, and the same thing that allows proteins to fold and living beings to operate in the way they do."

Artist's Note:

In *Synchrony Prevails*, I selected two circular designs from my marbling works. You can easily see where color droplets have been drawn out to extremely thin lines. I enlarged them for *Synchrony*. To complicate matters, I placed one design behind the other on the clear plastic. This demanded that I

make two separate paintings, one on each side of the plastic. (Painting them on clear plexiglas was not easy, but at least I could trace the designs!) To reproduce the distinct edges, I put tape along them. Then, was able to add color along the tape, which was later removed. (Tape does not turn corners along a curved line unless one makes many tiny slits along the opposite edge, which was labor intensive.)

COMPLEXITY: DEATH TEEMS WITH LIFE

1. Lynn Margulis, and Dorion Sagan, *What is Life?* (London: Weidenfeld and Nicholson, Ltd., 1995), p.156.

2. Trudy Myrrh Reagan, *Since Darwin, Everything Evolves,* poster for Darwin Day (unpublished), 2002.

3. Helena Curtis, *The Marvelous Animals, An Introduction to The Protozoa* (New York: Garden City, 1960), pp. 167-8 and Anna Kuchment, staff editor, "The Smartest Bacteria on Earth," *Scientific American,* June 2011, pp. 70-71.

4. Laura Elenes, professor of art at NAUM, Mexico City (private conversation, 1990).

5. Michael Gazzinaga, *The Consciousness Instinct* (New York: Farrar, Straus & Giroux, 2018), pp. 135–6.

6. Elisabeth Kübler-Ross, *On Death and Dying* (New York: Macmillan, 1969), in a radio interview about her book.

Artist's Note:

In *Death Teems with Life*, I was puzzled how I would suggest microorganisms. I certainly was not going to draw each one! But I observed a puzzling paint reaction in which combining two paint layers to make a new color didn't work. Some kind of repulsion forced the top layer into little tendrils that worked well here.

COMPLEXITY: CATASTROPHE!

1. Stuart Kauffman, *At Home in the Universe, the Search for Laws of Self-Organization and Complexity* (Oxford: Oxford University Press, 1995), p. 20. Kauffman is the first to admit his views are somewhat controversial.

2. Lisa Margonelli, "Collective Mind in the Mound: How Do Termites Build Their Huge Structures?," *National Geographic,* August 2014.
http://postcivilateum.blogspot.com/2008/10/termites-and-telescopes.html; also Philip Morrison, "Termites to Telescopes," *Nova,* Season 6, Episode 18. First Aired: December 1979.

3. Charles Perrow, *Normal Accidents: Living with High-Risk Technologies* (New York: Basic Books, 1984).

4. Mark Buchanan, *Ubiquity* (New York: Three Rivers Press, 2000), pp.15, 62. "It appears that, our world is at all times tuned to be on the edge of sudden, radical change, and that these ... may all be strictly unavoidable and unforeseeable, even just moments before they strike."

5. M. Mitchell Waldrop, *Complexity: The Emerging Science at the Edge of Order and Chaos* (New York: Simon and Schuster, 1992), p. 230.

Artist's Note:

To create the image of *Catastrophe!*, I had to mimic one, by destroying a failed painting. Acrylic paint is a polymer skin on a painting's surface. Removing it simply requires its solvent: rubbing alcohol. In my experiment, I saturated a large rag with it and clamped one corner of it to the edge of the painting. Then, I fanned it out in wrinkles across the painting. Removing the rag, I scraped off the softened paint for white lines. I brutally went into the bare plastic areas with a small rotary power tool to emphasize them, giving the effect of an explosion. Moreover, I drilled a few holes in the plastic. When shown with the light behind it (which my paintings often are, to exploit their transparent colors), these give the illusion of sparks.

TURBULENCE

1. Milton Van Dyke, *An Album of Fluid Motion* (Stanford, CA: The Parabolic Press, 1982).

2. Brian Koberlein, "Shake, Rattle and Roll" briankoberlein.com/2015/05/05/shake-rattle-and-roll/

3. Melanie Mitchell, quoted from Alex Marshack, *3D Radiative Transfer in Cloudy Atmospheres* (New York: Springer, 2005), p. 76.

Suggested Reading:

Theodor Schwenk, *Sensitive Chaos: The Creation of Flowing Forms in Water and Air* (London: Rudolph Steiner Press, 1965). Wonderful photographs.

EMERGENCE

1. Stuart Kauffman, *At Home in the Universe* (Oxford: Oxford University Press, 1995), p. 45.

2. ibid., Preface.

3. ibid., Preface.

Artist's Note:

In *Emergence*, a close look at the "tissue" reveals a symmetrical design, created not by regular geometric tiles of small elements, but small, irregular shapes. I am indebted to James Cannon, a mathematician at Brigham Young University, for the computer-generated group theory graph that formed the basis of this painting. His graph appears with the half title at the beginning of this book.

How, you may ask, could I inscribe this onto my painting using my small rotary power tool? I was working on a 45" wide sheet of clear plexiglas. By photocopy, I enlarged the small diagram to the size I needed, made myself a large light table, placed the diagram unto the plastic surface of my painting. Already it was partly finished with colored edges. I put a pale color the center, and traced through it. It took a week.

AFTERWORD

Werner Heisenberg, *Philosophic Problems of Nuclear Science* (Greenwich, CT: Fawcett, 1966).Quoted by Lawrence LeShan, "The Quotation Game: How can you tell a physicist from a mystic?" *Intellectual Digest*, 2/1972.

Artist's Note:

This 1971 block print was the first where I explored a question that I heard in a physics lecture: Is mathematics a tool to discover the underlying order in the universe, or does it explore those phenomena that are isomorphic (fit well) with the human construct of mathematics? The geometric design is based on the "Chinese Key" design, plotted on a warped grid, and stars from an actual star chart. I made a 20" X 30" piece of linoleum mounted on plywood for a block print. Into this I hand-carved the white lines and stars. I was able to print it on my dining room table by rubbing the thin paper with a spoon against the inked block.

PICTURE CREDITS
Essential Mysteries in Art and Science

THE WORLD OF SMALL AND LARGE
Solar flare — *NASA/Goddard Space Center, MIT "C3-class Solar Flare Erupts on Sept. 8, 2010" NASA/NDO*

Human heart — *123rf stock photo*

Subatomic particle interaction — *David Parker, SLAC, www.scienceimages.com (now defunct)*

NUMBER GOVERNS FORM
Fibonacci pinecone diagram — *The Power of Limits, Gyorgy Dosci (Shambala Publications, Berkeley)*

Romanesque broccoli *fractal* — *Photo by Myrrh*

Lacy leaves fractal — *Photo by Myrrh*

Iceplant with numbers — *By permission, John Edmark, Engineering, Stanford University*

ENERGY BECOMES MATTER
Sun seething — *NASA/CXC/SAO*

Star Formation Area — *NASA/CXC/SAO*

Black hole painting — *NASA/CXC/SAO*

Holmdel Antenna at Bell Labs (Murray Hill, NJ) — *Nokia-US/Murray Hill*

LIFE CREATES
Spiral rose — *Photo by Myrrh*

Parrot feathers — *123rf stock photo*

Radiolarian — *On Growth and Form, d'Arcy Thompson (Cambridge University Press USA, 32 East 57th St., New York, NY 10022), p. 160. This is the drawing that inspired my painting.*

Ammonite — *Texbook of Palentology, Karl A. von Zittel (London: Macmillan, 1913)*

BRAINS IMAGINE
Right Brain, Wrong Brain — *Cartoon by Myrrh*

Imaginary guitar — *Photo by Myrrh*

Tinguey's fountain, Paris — *Watercolor by Myrrh*

MINDS HAVE WANDERLUST
V838 Mons light echo — *NASA/CXC/SAO*

Stonehenge, 3000 BCE to 2000 BCE — *By permission of Cindy A. Pavlinac Photography*

Star Nursery — *NASA/CXC/SAO*

COMPLEXITY: INTERTWINGLED

Roots — *Photo by Myrrh*

Celtic Knot — *Dover Books*

Lisa Margonelli, "Collective Mind in the Mound: How Do Termites Build Their Huge Structures?" National Geographic, August 4, 2014

Complex number plane — *www.mathsisfun.com/algebra/complex-plane.html*

Supertopo Rock Climbing fractal — *www.enchgallery.com/fractals/fractal%20images/jam2.jpg (in public domain)*

COMPLEXITY: SYNCHRONY PREVAILS

Lorenz Attractor — *jonleyes.com*

Jupiter Red Spot painting — *NASA/CXC/SAO and a citizen-scientist painter*

Human Pyramid — *Photo by Myrrh*

Myrrh doing paper marbling — Photos by Helen Golden

COMPLEXITY: DEATH TEEMS WITH LIFE

Animal bone fragment — *Photo by Myrrh*

Fungi decomposing wood — *Wikipedia*

After a fire, Regrowth! — *U.S. Forest Service*

COMPLEXITY: CATASTROPHE!

Mudslide — *www.weatherwizkids.com (public domain)*

Domino effect — *123rf stock photo*

Crab Nebula supernova remnant — *NASA/CXC/SAO*

TURBULENCE

Laser light interference — Photo by Myrrh

Turbulence — Prof. Nassan Nagib, Illinois Institute of Technology, Chicago

Whitewater — Photo by Myrrh

EMERGENCE

Bacterial colonies — www.scienceimages.com (now defunct)

A baby emerges — Midwife Faith Gibson

DESCRIPTION: IMAGES OF ART BY THE AUTHOR

The World of Small and Large, 1993
45" diameter acrylic painting on acrylic plastic sheet 3/16" thick, engraved with small rotary power tool.

Energy becomes Matter, 1997
45" diameter acrylic painting on acrylic plastic sheet 3/16" thick, engraved with rotary tool.

Number Governs Form, 1994
45" diameter acrylic painting on acrylic plastic sheet 3/16" thick, engraved with rotary tool.

Life Creates, 1993
45" diameter acrylic painting on acrylic plastic sheet 3/16" thick, engraved with rotary tool.

Brains Imagine, 1995
45" diameter acrylic painting on acrylic plastic sheet 3/16" thick.

Intertwingled, 1997
45" diameter acrylic painting on acrylic plastic sheet 3/16" thick.

Death Teems with Life, 2003
45" diameter acrylic painting on acrylic plastic sheet 3/16" thick.

Minds Have Wanderlust, 2007
45"diameter acrylic painting on acrylic plastic sheet, engraved with a dental tool.

Synchrony Prevails, 2005
45" diameter acrylic painting on acrylic plastic sheet 3/16" thick, painted on both sides.

Catastrophe!, 2006
45" diameter acrylic painting on acrylic plastic sheet 3/16" thick, incised with small rotary power tool, and small drilled holes to simulate "sparks."

Einstein, 1995
Acrylic painting on acrylic plastic sheet, engraved with small rotary power tool. The paint is in the engraved lines, with the surface wiped clean.

Science is System Searching for System, 1971
Block print 20" X 30" edition 6 (one in blue).

COLOPHON

Cover and Interior Design by Robert Perry
Robert Perry Book Design, Palo Alto, California

Printing and Binding by JP Graphics
Santa Clara, California

Display Typeface: Skia, Optima
Interior Typeface: Futura

Cover Stock: GPI Matte
Text Stock: Endeavor Velvet

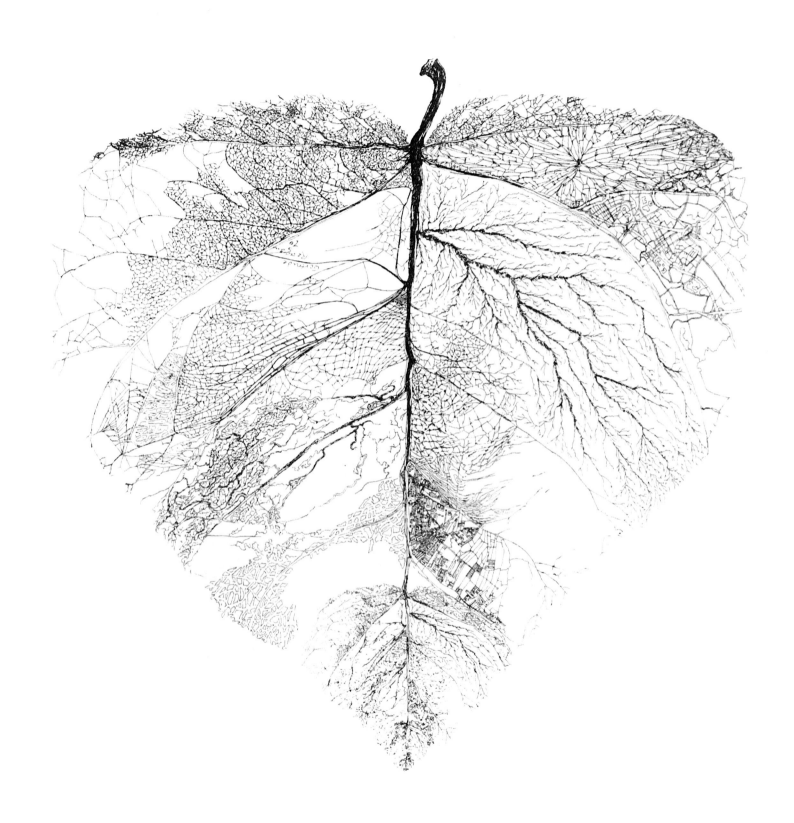